MAGRITTE

PERE GIMFERRER

MAGRITTE

EDICIONES POLÍGRAFA, S. A.

© *1986 Ediciones Polígrafa, S. A.*
Balmes, 54 - 08007 Barcelona (Spain)

Reproduction rights:
A.D.A.G.P., Paris - L.A.R.A., S. A., Madrid
Translation by Kenneth Lyons

I.S.B.N.: 84-343-0498-8
Dep. Leg.: B. 27.589 - 1987 (Printed in Spain)

Printed in Spain by La Polígrafa, S. A.
Parets del Vallès (Barcelona)

IN MAGRITTE WEATHER

"It's Magritte weather today": Max Ernst's celebrated phrase seems, with all the precision of poetic definition, to delimit the terms of the problem definitively and, for that very reason to cancel it out in some way. Apart from those of a biographical nature, the approaches that have hitherto been made to the world of René Magritte have, in fact, been mostly poetical. In this field Magritte himself is at once insuperable and indescribable. It is impossible to really put into words what his works express in purely plastic terms; nor can one imagine that any poem could achieve anything like the works' immediacy of revelation, imbued with irrefutable force. It is true, of course, that a work by Magritte acts in exactly the same way as a poem would; but there is no poem that acts like a work by Magritte. In this sense Ernst's phrase, however evanescent it may seem at first glance, attains a maximum of precision: Magritte is, in fact, a sort of "weather," and even a whole climate—a propensity of thought, perhaps what some might call a state of mind—a world or an atmosphere. It is in this that his specific excellence is to be found.

Magritte is certainly not the only artist of this century who has painted things that do not exist and are in fact inconceivable within normal perceptions of phenomena. His *confrères* in this approach include Ernst himself, Chirico, Tanguy, Dalí, and Delvaux—to mention only some of the best known artists who never (except for Ernst, in certain areas of his work) abandoned what is usually known as "figurative" painting. This of course leaves out painters like Joan Miró or André Masson, who did depart considerably from the usual system of representation. And yet in no way can any of the painters who, like Magritte, depicted "impossible things" be confused with him (in passing I may say that it would be pretty difficult to confuse any of them with any of the others, although that is not a question that concerns us at the moment). Given Magritte's artistic premises, no matter how exceptional his individual talent may have been, what he actually achieved was, in theory, well within the reach of any of his contemporaries. It is no disgrace for an artist to create a "school," or for his style to coincide with those of others. Nevertheless, although Magritte has had posthumous imitators (some of whom, admittedly, have merely popularized or trivialized his art) and has exerted a lasting, latent influence on the sensibilities of our time, if we go to the heart of the matter there is no painter remotely approaching his stature who can be either

compared to or confused with him. In this respect, too, Magritte is irreducibly unique.

Those with the closest affinities to the artist—Max Ernst, for instance, or Louis Scutenaire or Patrick Waldberg—produced a poetical atmosphere analogous, though not identical, to that of his canvases. At what might at first sight seem to be the opposite extreme, an essay by Michel Foucault proved to be the most important contribution to the study of Magritte. In an apparently paradoxical procedure, Foucault applied to the artist's works the very premises that his paintings either avoid or openly reject, examining Magritte's output as a painter according to the usual laws of representation and the data that form part of the usual viewer's phenomenological experience. Foucault then proceeded to a description that was quite deliberately intended to appear tautological, in a purely Socratic exercise.

What Foucault did was to take to its ultimate consequences (consequences irrational precisely because of their extreme concern for scrupulous rationality) the instinctive response elicited by Magritte's canvases—or, to be more exact, by what exists in them—the response called forth not, that is to say, by their hypothetical (and, when all is said and done, utopian) reference to reality, but by their effective plastic reality. It is a fact that a work by Magritte provokes a particular reaction, which conforms to certain laws of internal logic that govern plastic works in general, but not specifically those of Magritte. Out of the simple examination of this fact—which in itself is so well known as to be useless in any critical interpretation—Foucault succeeds in extracting the highest degree of empathy for Magritte that is attainable in an essay. His extreme rationalization of what is pure evidence constitutes a subversive exercise as penetrating and lucid—and, at bottom, as poetic—as the synthetic formula invented by Max Ernst.

Up to now I have referred only to those who, from a position of friendship or affinity, and occasionally from both at once, were advocates of Magritte's work. It is impossible to go further than Ernst or Foucault along the path they chose to follow; possibly it was only by being Ernst or Foucault that either of them went so far. But perhaps there may be another, more oblique, way of approaching Magritte, one that has the additional, incidental advantage of meeting an objection that was sometimes made to the artist's work even during his lifetime. It must be admitted, indeed, that poetic approaches such as those of Ernst or Scutenaire are to some extent acritical by definition, while Foucault's study, important though it may be in many respects, cannot be regarded as belonging to the field of art criticism in the strictest sense. Art critics in different countries have from time to time expressed reservations about Magritte—not, in fact, about his early, still rather tentative paintings, nor yet about those atypical works of his *période vache*, but rather the very works that have been the basis of his fame, that constitute the real nucleus of his total *œuvre*. Some of those critics have talked of literary painting; others have hinted, or openly asserted, that the painter's values were exclusively, or at least principally, literary. The most severe of these objections could serve

to confirm that Foucault's analysis demonstrates the excellence and conceptual singularity of Magritte's art, but neither proves nor can prove anything about its pictorial nature.

Here we may find ourselves exploring barren ground. There is no sense in comparing Magritte with artists such as Braque, Mondrian, or Pollock, whose raw material is pure pictorialism. Only purely pictorial excellence can be expected from them, just as only the most refined verbal excellence can be expected from Rimbaud or Mallarmé. Does not the greatness of Mallarmé invalidate to some extent that of Lautréamont or of Germaine Laye, who were far from operating, like Rimbaud or Mallarmé, through the sheer semantic, sonorous expansion of words? In comparison with Rimbaud or Mallarmé, admittedly, we do find in both Nouveau and Lautréamont a certain margin of verbal "imperfection," as of something "unfinished"; but no poet can be asked to write poems other than his own. It is as difficult to imagine Lautréamont producing the *Sonnet en ix* as it is to think of Mallarmé composing *Les chants de Maldoror*. Particularly from the viewpoint of Surrealism—and that is the only one from which Magritte's activities can be fairly judged—in the evolution of the artist's painting may be seen a continuing subversive attitude that parallels the trenchant condemnation of "retina painting" implicit in the work of Duchamp.

It is true that Magritte's principal source of income for many years was publicity drawing or industrial design (wallpapers, advertisements, and publicity for couture houses). It is likewise true that, unlike other painters who have engaged in this sort of work (Antoni Clavé, for instance, who in his younger days did many posters for cinemas), Magritte's works—especially his most highly appreciated and characteristic works—always reveal something of the working methods used by artists who engage in publicity work. And finally it is true that, whatever judgment we may be inclined to pronounce on them, it is not the works of his "Renoir period" nor yet those of the *période vache* that have been responsible for Magritte's great fame and influence but rather those that describe, in meticulously realistic technique, associations that are impossible in real life. This technique—and even, we must perforce admit, some of these associations—belong to some extent to the same order of things as his paintings for advertising campaigns. (Indeed, although I mention the fact only as a curiosity, in 1986 an important publicity campaign promoting computer software used a strictly Surrealist oil painting by Magritte as its graphic motif.)

There is no need to stress contemporary recognition of the artistic merits of graphic publicity—as seen in the famous posters of Toulouse-Lautrec, for instance—or to make any mention of the vast increase in the awareness of design that has taken place over the last few decades. It is sufficient, I think, to point out that the chief characteristic of Magritte's works (particularly when one sees them "in the flesh," so to speak, since photographic reproduction always modifies, be it ever so slightly, this phenomenon) is that they are authentic "dream advertisements." The logic that prevails in them is,

undeniably, the logic of the world of publicity—in which, as in magical thought, according to Frazer, the workings of contiguity or analogy take the place of those of causality. Moreover, the orientation of Magritte's works vis-à-vis traditional painting in oils is not so very different from that of advertising art in relation to "serious" art.

In both publicity and Magritte's Surrealist paintings, we are presented with something that is at once a simulation and a substitute: the appearance, at first glance, of a traditional oil painting, but only the appearance ; in exactly the same way as we are presented with the appearance—again, only the appearance—of a traditional realistic representation. In this respect Magritte is as lucidly critical as Duchamp of what the latter called "retina painting," but Magritte chooses to display his criticism in another way; one that is more oblique and yet at bottom more homologous, which he chooses in order to make explicit his radical disagreement with the ordinary perception of everyday reality.

Magritte's capacity for combination seems inexhaustible—and since nobody but he could exercise it, his physical disappearance admits no palliatives. Magritte can be imitated, albeit in a sterile fashion, but he cannot be replaced. We often find that his true successors are those who seem the least likely, for his attitudes towards art and life can be inherited, but not the iconographical repertoire that is his alone. And yet it is really rather remarkable that an artist whose imagination was so indefatigably varied should have been so firmly convinced of the need to rework some of his most important paintings over and over again. True, there is a long tradition of artistic revision in the history of art; any well-educated person will recall the two versions of Watteau's *Embarquement pour Cythère*. But Magritte did not work with previously existing themes, which by their nature admit different variations or concurrent treatments; nor did he work on commission, as did such painters as Bellini, Canaletto, and Fortuny, who had to cater for a clientele that demanded new formulations of one subject. Magritte's returns to certain themes belong rather to another tradition in art history. Like Joan Miró— an artist from whom he differs in a great many aspects, but with whom he is morally at one in his radical adoption, to its ultimate consequences, of the Surrealist attitude—Magritte returned again and again to certain obsessive motifs, which on first encounter afforded him an initial shocking revelation. These motifs were imbued with a poetic potential akin to that of the *objet trouvé*, one that in Magritte's case came into play exclusively thanks to the operation of art.

What is probably Magritte's most celebrated work, *The Empire of Lights*, provides us with one of the most characteristic examples of the painter's way of reacting to the obsessive nuclei of his imagination. Magritte painted no fewer than ten versions of this work, the last of which, significantly enough, remained unfinished owing to the artist's death, so that we may say that this image accompanied him over the two final decades of his life, until his very last moment. Any viewer who is in the least familiar with Magritte's work

or is even minimally interested in contemporary painting is acquainted with the subject of *The Empire of Lights*, which does not vary substantially in the course of its different versions. It is a painting in which there is no sign of any human or animal figure: in short, no living beings at all. And yet the scene is not static or lacking in movement, for motion is evoked by the ethereal cotton-wool clouds floating across the upper part of the painting. It is not this part, however, that principally attracts the viewer's gaze, which is inevitably drawn first to the lights that give the picture its title: light from one or more lampposts and one or more windows in a building apparently uninhabited and totally devoid of all human activity. This is the only element in the work that is absolutely fixed and unalterable. The number and arrangement of lights and windows, the inclusion of both (as is most common) or of only one—occasionally the lamppost is omitted, a circumstance all the more surprising inasmuch as the feature of *The Empire of Lights* most immediately recalled by the vast majority of viewers is in fact that very lamppost, or lamppost—are factors that vary from one version of the work to another. This is true (even more so) of the possible presence, in the lower part of the picture, of the still waters of a river, pond, or canal in which the light from the lamppost can be reflected.

From this it can be seen, of course, that the area in *The Empire of Lights* that most immediately attracts and retains the viewer's interest is a nocturnal scene. Absolutely of the day, however, is the clear blue sky dotted with floating white clouds that occupies the upper part of the scene. A sky like the one depicted naturally rules out any illumination like that shown in the lower part, and especially the penumbra dispersed by such illumination. There can be no doubt that the work would not be nearly so disquieting without this contradiction. But unlike other pictures by Magritte, in which one can immediately see the impossibility (in accordance with the most elementary laws of physics) in real life of what is represented on the canvas, in my opinion what most impresses the viewer about *The Empire of Lights* is not the fact that such physical laws should have been transgressed, but rather the special quality that is gained—and indeed, heightened—through this transgression. The truth is that the vast majority of viewers do not quite realize that the scene represented is not realistically presented.

Undoubtedly the house or houses with the lighted windows, and the light from the lamppost, when there is one, are given so much plastic emphasis that they force one to accept the scene fully and without reservations. More or less consciously, the viewer tends to believe, for instance, that what he sees is simply an anomalous twilight in which darkness has come on much more quickly, possibly owing to the shadows in the dense foliage of the trees, in the area of the house than in the vault of heaven above; or else it is taken for granted that the house lights—since nobody seems to be home—have either been left on outside of normal hours or have been switched on prematurely. None of these explanations is acceptable, of course, since the darkness enveloping both the house and lamppost cannot be taken for anything but true nocturnal darkness. The poetical impact of this work on the viewer derives

not from any transgression of the laws of meteorological verisimilitude but from the visual authority with which the lights of the house and the lamppost are presented. What is essential in this work, and more generally in all of Magritte's poetical imagination, is not so much the violation of verisimilitude, and the terms in which that violation is carried out, as the new plastic entity to which it gives rise.

On the subject of *The Empire of Lights*, Magritte himself wrote: "For me the conception of a picture is an idea of one or several things that can be made visible through my painting...The conception of a picture—that is to say the idea—is not visible in the picture itself; an idea cannot be seen with the eye. What is represented in the picture is what is visible through the eyes, the thing or things of which I have found it necessary to give an idea. Thus, the things represented in the picture *The Empire of Lights* are the things of which I have had the idea: is to say, exactly, a nocturnal landscape and a sky such as we see in broad daylight."[1] These words of Magritte's are extremely revealing in their apparent simplicity; on reading them one cannot help recalling Leonardo da Vinci's celebrated description of painting as *cosa mentale*; or calling to mind, in an order of things which is literally closer still, a certain moral tale by Ramon Llull: "There was once a painter who painted the image of a man on the wall. While that painter was painting that image, many men who were close to the painter praised the painter for the great mastery he showed in painting that image. And it happened that the painter asked one of those men who were praising him whether he was more deserving of praise because of the imagination he had within himself in imagining the image he was painting, or whether he deserved praise rather for the image that he was creating." Undoubtedly, it was not by chance that Ramon Llull was one of the writers whose works were recommended reading for the Surrealists; the terms in which Llull describes the operation of painting, at all events, are approximately equivalent to the words of Magritte on the subject of *The Empire of Lights*.

Any approach to the previous idea will explain the foundations of Magritte's fascination; but the fascination in itself does not depend on the idea but rather on the object—that is to say, on the work. Thus in the case of *The Empire of Lights*, for instance, it is not the mere coexistence of day and night—the previous idea—but the visible object engendered by it (a plastic sublimation of the artificial light that could not occur in any other way) that speaks to the imagination of the viewer. The viewer, accepting the scene as it is presented to him, accepts its contradictions as the necessary pictorial artifices that sometimes transgress the laws of verisimilitude, after the fashion of those strained perspectives, foreshortenings, or anatomical excesses to be found in Mannerist painting, or of the unreal arrangement of real objects that we sometimes see in such eighteenth-century forms as the *capriccio* or the *veduta fantastica*.

1. René Magritte: "L'empire des lumières," in: *Écrits complets*. Flammarion, Paris, 1979, p. 422.

The idea is more visible in another celebrated picture by Magritte, *Dangerous Relationships*. The transgressions of verisimilitude contained in this work have been related in detail by Foucault in a most productive critical work. Most viewers, however, will merely feel a vague uneasiness without being able to specify the exact scope (which is really explicable only through a thorough analysis) of the deviations from verisimilitude that appear in this picture. They will see, of course, that the looking glass, instead of reflecting, is transparent, and that the position of the woman's torso is inverted in relation to the part of her body not framed by the glass; but will probably not perceive other discontinuities and peculiarities such as the proportional size of each part of the body, the position of the hands or the shadow on the wall. Grasping the idea behind the work will help the viewer to reconstruct Magritte's creative mechanism, but the idea will not replace—though it may explain—the work's imperious plastic effectiveness.

Quite frequently, Magritte's pictorial operation can be summarized in comparatively simple and explicit terms: the terms proper to poetical language. For example, in his works the oppositions between the natural world and the artificial world on the one hand, and between open space and closed space on the other, converge in a single plastic theme that appears in at least three important reworkings: *The Listening Room* (which might perhaps be equally well translated as *The Listening-in*), *The Anniversary*, and *the Tomb of the Wrestlers*. In all three, inside a space that is at once *closed* and *artificial*—a room, absolutely new and clean, but without any furnishing except for a curtain at the window, and in *The Listening Room* a room without even a curtain—there is an element of the *natural world*—a rose, an apple, a mineral. This element, because of its nature and because of the immense size or scale with which it is presented, we associate immediately with the notion of *open space*. More complex but equally clear-cut is the operation carried out in the case of *The Golden Legend*, in which we witness one of the actions that constitute the very foundation of poetical language: the transition from simile to metaphor.

It is true, indeed, that it can be said of the great white clouds that appear in the different versions of *The Empire of Lights* that they look like loaves of bread. It can be said, but in fact it is not said, because this would really be what is called a "descendent image," insofar as it compares an object with another of a less lofty nature, thus inverting the magnifying objective of imaginistic transfiguration. The poetics of the avant-garde movements, however, do occasionally make use of the descendent image (especially, for instance, among the works of the Russian Futurists), since for them the sublime is not necessarily associated with the lofty but rather with the unusual. Since the clouds look like loaves of bread, then, Magritte's procedure is quite consistent: in *The Golden Legend* the clouds do not *look like* but *are* loaves of bread in the serene blue sky. Here we may observe the thaumaturgical power of the image. A simile merely relates two elements through an analogy that is sometimes tangential or fortuitous; a metaphor constructs, on the basis of that analogical relationship, a new reality that exists only in the poetical word.

The loaf-clouds in *The Golden Legend* are, precisely, a visual metaphor—or, still more precisely, the visualization of a metaphor, transformed into a new order of reality that exists only in the picture.

The relationship of what is represented in one of Magritte's works to the title of that work, and the fixed, variable, or combinatory value acquired by each element from one work to another, can guide us to the central nucleus of the painter's plastic operation. As everybody knows, it frequently happens that the titles of avant-garde paintings derive their subversive force from a precise and submissive attempt at description. For instance, nobody will dispute, after closely examining them, that paintings such as Picabia's *Very Strange Painting on the Earth*, Duchamp's *Sad Young Man in a Train*, Ernst's *The Robing of the Bride*, or Miró's *Dutch Interior* (four pieces that at least have in common that they belong to the Peggy Guggenheim Collection in Venice) bear titles perfectly suited to their plastic reality. Yet it would be difficult to imagine anybody deciding, without previous knowledge, to assign such titles to them; not difficult because to do so one would have to be thoroughly acquainted with a certain field of knowledge (as, for instance, Renaissance and Baroque painters were with the themes of classical mythology), but difficult in the sense that the things one needs to know in this case are not part of a repertory available to everyone but belong exclusively to the artist. Magritte's titles, however, function in another way, as an additional factor, a new element of criticism and disturbance.

Let us examine one of the more moderate cases—by which I do not mean a work in which it is quite obvious that the painter is aiming at a maximun of tension between title and picture and a maximun of the illogical in the former (as in *Time Transfixed*, a title in itself entirely irrational unless it is taken as a criticism of Bergson's philosophical terminology, for designating the image of a smoking steam locomotive embedded in the fireplace of a bourgeois dining room). Let us take, rather, a case in which it is comparatively easy to reduce the possible genesis of the manner to rational criteria, even though it be purely by way of conjecture. Let us take, then, a canvas such as *The Beautiful Relations* as our starting-point. Like *Time Transfixed*—and, I should add, like the great majority of Magritte's works—this canvas is based on the effect of strangeness derived from the juxtaposition in one and the same space of several elements, none of which by itself would cause any surprise, since they all belong to everyday reality. Let us for the moment forget about the great sky with white clouds on a background ranging from blue to pink, and the tiny village with lights showing in its apparently Lilliputian windows that can be seen at the bottom of the canvas. These elements (which contain hints of *The Empire of Lights*) support what constitutes the real subject of the composition, which cannot be defined as other than a human face. This face is not only of cosmic proportions (as though it were the unimaginable face of the sky, or the world, nature personified) but is also quite devoid of features, being only partially constituted of human elements. It is an allusion to a face, a face that is uniquely elided.

Nevertheless, it seems somehow typical of Magritte that the theme of the cosmic face, and at the same time of the non-face, the face that exists only by allusion and is not even entirely anthropomorphic (a theme extremely characteristic of contemporary art, and more often than not, as in the work of Ernst, quite frightening) should here strike us as being perhaps a little irritating, but by no means tragic or terrifying; in fact hardly more than vaguely threatening. This is so not only because of Magritte's temperamental penchant for "everyday unusualness" and avoidance of tragic pathos (insofar as it would mean favoring the exceptional, and thus impairing that continuity of the unusual which his art postulates), but also because the elements that go to make up this face are, to some extent, comic elements. Only the eye on the left-hand side—the one human eye—escapes this connotation. We may, perhaps, be taken aback by its hypnotic fixity, the absolute whiteness of the cornea contrasting with the tremendously intense blue of the pupil, or by the pink borders of eyelids, totally innocent of lashes; but even in such an emblematic role this eye is in itself neutral, by which I mean perfectly serious. The same can hardly be said of the other elements forming this face. The lips are intensely red, as heavily painted as a lipstick advertisement, and quite unmistakably feminine (whereas the severity of the eye suggests rather a masculine personality); the nose is an exaggerated pink conk like a clown's (always supposing that it is a real rather than a false nose, since we cannot see the nostrils); the balloon, finally, not only offers the burlesque contrast between its almost spherical shape and the transversal narrowness of the eye on the left but, for today's viewer, makes by its very presence an allusion to a past age invented by Jules Verne, at once chimerical and anachronistic. This is everydayness, yes, but it is the everydayness of a superseded yesterday. And yet, from the convergence of these very doubtful elements—a single eye, an exaggerated nose, a pair of vamp's lips, a hot-air balloon—a face emerges that gazes out at us and occupies the whole sky. There can be no doubt about it; what binds these elements together is what the French call *des belles relations*; not in the sense of harmonious coexistence but in the typical bourgeois sense of "being well connected," i.e., having friends who are both influential and socially impeccable. Magritte's title in this case is perfectly descriptive, although it may indulge, in passing and on the rebound, in ironical commentary on another aspect of everydayness—a cliché from the horrid, priggish repertoire of the petite bourgeoisie.

Let us now look at another canvas, in which one of these elements appears again. The canvas in question is *Justice Has Been Done*, a work that contains, moreover, elements that are also found in other works by Magritte. To the right, in effect, the field of vision is delimited by a sort of board fence identical to the one we see in the 1938 version of *Memory*; the line of marine horizon that closes the perspective in the lower part of the canvas, however, recalls that appearing in the 1948 version of *Memory*, not reproduced in this book. The upper part of the canvas is largely occupied by a hot-air balloon. This balloon, however, is not plain like that in *The Beautiful Relations*, but profusely ornamented; nor is it empty, for it is, as it were, "manned" by two tiny figures, whom we may suppose to be the proverbial nineteenth-century

savant and his no less proverbial assistant. In this work the balloon, floating over the head of a character dressed in a white tunic (a portrait of Harry Torczyner, who was a friend of Magritte, later the artist's biographer, and an authority on his work), is actually intended to evoke the condition of that character, after the fashion of those allegorical representations one sometimes finds in classical portraiture. Torczyner, in fact, was an international lawyer, whose work entailed a considerable amount of travelling: hence, on the one hand, the Socratic white tunic (Torczyner could be regarded as a Peripatetic, all the more so since dialectic formed part of his activities) and, on the other, the hot-air balloon (since most of Torczyner's travelling was done by air). In an admirable and revealing letter, Magritte mentions these points and then adds, in explanation of his choice: "The archaic nature of the hot-air balloon (despite its relative youth—around 200 years?) sets it as much in the past as the strolls of the philosophers. Socrates gazing up at a jet plane would be a vulgarity best avoided."[2] The title, *Justice Has Been Done*, suggested by a phrase used by the sitter's wife when she saw the picture, definitively expresses in an elliptical way that idea of agreement to the new reality proposed that was Magritte's goal. It is equivalent, in short, to the corroboration of the likeness that would be expressed on viewing a traditional portrait, but at the same time it means an acceptance of the visual equilibrium resulting from the composition.

Although it may occasionally be through a voluntary and very successful *reductio ad absurdum*, some of Magritte's works display a fairly rational combination of elements, explained by an equally rational title. This is the case, for instance, with *The Collective Invention*. Now, a mermaid, like any other mythological creature, may indeed be fairly regarded as a collective invention; and since a chief characteristic of several mythological beings—the mermaid and the centaur being the best-known—is that they are half human and half animal, there does seem to be a certain logic in the idea of a mermaid who has the torso and head of a fish but is a woman from the waist down. To be sure, the operation is rather disturbing in several senses, beginning, perhaps, with its effect on the viewer's eroticism. The pubic hair and guessed-at female sexual organs, as well as the soft curve of the thighs, are (unlike the images in the works of such a painter as Paul Delvaux, from whom Magritte declared himself to be very different) totally lacking any tinge of sexuality, their erotic possibilities cancelled out by the obtuse, distressing eye of the fish. The principal visual interest of this picture, in fact, lies in the nucleus formed by the head of the fish in the foreground, its rearing fin behind, and the sea in the background with its ripples visibly in harmony with the outline of that fin. We quite clearly perceive not only that the eroticism of the traditional mermaid is of a psychological nature and based on the face but also that, however disjunctive the erotic obsession may prove, an erogenous zone—in this case the pubis—can be neutralized simply by dissociating it from the rest of the body; i.e., by taking the fetishistic disjunctivism

2. Letter to Harry Torczyner, 26 July 1958, *in*: Harry Torczyner, *René Magritte. Signes et images.* Draeger/Vilo (1977), p. 213.

to its last and strictest consequences. Thus, the ultimate theme of *The Collective Invention* is really the plastic dissolution of the erotic myth of the mermaid, in what Magritte himself calls "the answer to the problem of the sea."[3] This ocean background—as majestic and lyrical as one of Vernet's seascapes—finds its natural correlation in the disquieting fish's head, and dilutes or dissipates the plastic entity of the female pubis.

Apart from this, the central combinatorial motif in *The Collective Invention* is, after all, simply a new manifestation of what was Magritte's fundamental obsession: the coexistence, in the plastic space of the canvas, of all that is different, opposed, and irreconcilable in the space of our experience of phenomena. In a way that is quite as eloquent and vivid as that of El Greco in *The Burial of Count Orgaz, The Empire of Lights* expresses this experience, which is really a rending that leads to a different reality, an opening into the preternatural. In other works we have seen the contagion between open space and closed space, and between the natural world and the artificial world. In *The Collective Invention* this sort of contagion, mutual transfer, or secret intercommunication presents us with a further variation: the transition between the animal world and the human world, which will be echoed or paralleled in other such transitions or permutational exchanges among the classic kingdoms of nature (mineral, vegetable, and animal, particularly) and, in frequent combination or correlation with them, between the animate and the inanimate. Thus a veritable constellation of variables is established: natural-artificial, open-closed, human-animal, animal-vegetable, vegetable-mineral, animate-inanimate, to mention only the most obvious combinations. Naturally, it is not only Magritte's poetical imagination that rests on the rotation of this repertoire of signs, but, in general, all that is imaginary in fantasy and myth, and most particularly the imagery of Surrealism. Even the theme of the masking or elision of identity by means of the non-face— extreme examples of which can be found in the cloth-wrapped heads of *The Lovers*, the total absence of any face at all in *The Healer* or *The Liberator*, or the replacement of the head by an apple in *The Idea*—is in line with this same fundamental dynamic. At the same time, the appearance on one hand of a lunar face in a sphere very similar to the apple in *The Art of Living*, and the representation on the other in *The Postcard* of the character seen from behind or apparently absorbed in the contemplation of an apple suspended in the sky in front of him, represent two other phases of the same basic idea of decapitation by fruit or moon-dwelling animism.

All of these transactions I have been describing, although they do make us realize the conceptual subtlety of the dream mechanisms in Magritte, do not exhaust or even really explain the intrinsic fascination of his works, which are first and foremost plastic presences. In the mind of the viewer they leave equally the impression of a subtle, subversive displacement of the elements of the visible world, and the memory of a notable clarity of form and an

3. René Magritte, *La ligne de vie I*, a lecture given on 20 November 1938 in the Musée Royal des Beaux-Arts de Amberes, *in: Écrits complets*, p. 111.

obsessive sense of color. Magritte would be conceptually great (and that is, at least, one way of being great) if he were no more than the medium or the place of certain exchanges and transactions of appearances; but he is also the creator of a plastic world, which is something different from the mere conceptual decomposition of the elements of which it is composed. In other words, Magritte's greatness does not consist solely in having carried out a series of permutations that violate or call into question conventional perception but in having created through these works a disquietingly autonomous plastic world.

This is perhaps particularly noticeable in Magritte's works that deal not so much with the combinatorial interchange of objects as with the fusion or disappearance of limits between them. By this I mean the works in which Magritte must not aspire above all (in his own words) to "an objective representation of objects,"[4] for the sake of which he establishes as a basic premise what he calls (defiantly preempting, in the Surrealist fashion, a reproach often visited upon him by the traditional critics) a certain "absence of plastic qualities."[5] In other words, these works exemplify a certain refusal on Magritte's part to paint in any way other than that most readily identifiable with the stereotype of the viewer's experience, which he intends to violate. Magritte's own comments in this regard could hardly be more lucid. In a letter written to Paul Nougé in November 1927 he says: "I believe I've made an altogether startling discovery in painting: up to now I used composite objects, or perhaps the position of an object was enough to make it mysterious. But...I have found a new possibility things may have: that of *gradually* becoming something else—an object *melting* into an object other than itself. For instance, at certain spots sky allows wood to appear. I think that this is something totally different from a composite object, since there is no break between the two materials, no boundary. In this way I obtain pictures in which the eye 'must think' in a way entirely different from the usual..."[6]

And unequivocal example of the foregoing is *Discovery*, a picture Magritte painted around this time and to which he himself refers in the letter above when he says, almost by way of example, that "a nude woman has parts that also become a different material."[7] It is worth noting that Magritte's description here differs from those he gave on other occasions, in that here he does not go a step beyond the ordinary perception of the viewer, with whom in this sense he equates himself. When we examine *Discovery*, our first impression is that the picture before us is the portrait of a nude woman whose body is covered with tattooing. Very quickly, however, we realize that her skin is not tattooed, nor even covered with, for instance, paint or ink. There

4. *La ligne de vie I*, lecture quoted, p. 107.
5. *Íbid.*, p. 108.
6. Quoted *in*: Harry Torczyner, *op. cit.*, p. 213.
7. *Íbid.*

is nothing drawn or engraved on it, but in some parts the skin itself appears to become something else: at some points we seem to see a succession of streaks like the stripes of a tiger, and elsewhere the skin tends rather to suggest the varying roughness of tree bark. Nevertheless, no matter how disquieting this polyvalence may be, in *Discovery* the two materialities that alternately occupy the viewer's visual perception still have in common their allegiance to the realm of things solid and animate, whether it be the human and the animal worlds or even possibly the vegetable kingdom. But it was not long before Magritte's art provided an abundance of still more complex possibilities, confronting the solid with the liquid and the gaseous, and presenting them, moreover, in conjunction with other combinatorial themes already mentioned.

Thus, for instance, in *Decalcomania* we find intertwined the theme of the *double*—the split identity—or of *repetition* (i.e., at once the reflection or shadow and the iconic duplicate) and that of the communicating vessels between open environment and closed environment, which is here further reinforced with that of the transition between the solid and the gaseous and between man and the ether. The character on the left of the picture is, in effect, standing in the open air facing the vast sky with its great floating white clouds. On the right of the picture, however, the shadow or reflection or double of this character, situated in a closed environment and facing the curtain of an interior, is turned into a mere outline that contains, at exactly the same height as on the left of the picture, sky and clouds from the part corresponding to the character's bowler down to approximately the middle of his torso, and in the lower part of the shadow torso the expanse of sea of which in the left-hand half we can only see the beginning. The same communication between the human identity and the cloud-peopled sky appears in a fairly early and technically atypical work, *Napoleon's Mask*, a painted plaster cast in which the funereal impassiveness and the blind eyes are subtlely transmuted in the dissipation of the Magritte sky, with its scattered group of clouds setting off the cheekbones, the brow, the skull, the cheeks, or the neck of the Emperor, so that something essentially immobile—a mask at once monumental and funerary in its hieratic quality—is placed in constant transition towards all that is more mobile and changing.

The same central motif presides over *The Large Family*, in which, over a choppy sea, we see the flying silhouette of a bird of gigantic proportions yet not at all frightening in appearance. Rather, it is imbued with a sort of serene majesty, the interior of its outline occupied by the everlasting sky with white clouds sailing across it. Air in the air, in this bird the animal and gaseous worlds converge. Fair enough, but it is also impossible to avoid the impression that what we are shown here is the negative, the duplicate, the shadow or projection of the bird rather than the bird itself; its iconographical essence, if you like, rather than its tangible existence. Another, later version of the same theme, *The Large Family*, done fifteen years later in 1963, and not reproduced in this book, presents exactly the same plastic composition, the only difference being in the coloring of the sea and the sky in the background (i.e., the part not included inside the silhouette of the bird). These tend to

concentrate light blue or related tones in the lower part of the canvas, so that the continuity established between the sea and the sky in the earlier version now also comprises the part of the sky contained within the outline of the bird—at its start, at least. In the bird's crop and above all in the wings we certainly still find the impression of volatility (a double impression, given both by the opening and spreading of the wings themselves and by the internal movement suggested by the clouds. This volatility opposes, even by virtue of its simple, radiant clarity, the static character of the firmament, which gradually grows more ominously somber as our gaze moves up the canvas, to a clearly threatening storm in the upper area.

This coexistence of elements, although pleasant enough in the examples I have given up to now, can become a most disturbing confrontation. The cosmic combat of giants show in *The Battle of the Argonne* is such a confrontation, in the empty sky over a little village, between a rock and a huge storm cloud—two of the four classic elements, inanimate in themselves but silently animated by their position as jousters in a tourney umpired, and at the same time visually counterpoised, by the thin line of the new moon. Equally inanimate, the objects in *Personal Values* derive their subversive potential, as Magritte himself pointed out in a letter, from the simple fact that, thanks to their dimensions, they are deprived of whatever practical utility they may possess in everyday life; really, however, the whole composition would not amount to more than a variant of the conception of *The Listening Room* (objects of unusual dimensions, and artificial ones in this case, within a closed space), were it not that here the sky performs the functions of a wall and so presents another confrontation, not only between the manufactured or artificial and the natural but, once again, between the solid and the gaseous. Thus it traces a new front line of challenge parallel to that established by the hypertrophy and bizarre arrangement in the room of the comb, the wineglass, the match, and the shaving brush. Nobody but Magritte could have painted this scene; anybody who questions the specific aesthetic entity of his work must lay down such arguments as he may have in the face of this image, which is only conceivable in pictorial terms, only exists because painting exists: *ut pictura poesis*. The weather in this room invaded by the clouds and the blue belongs to no place in particular. We are living, for good by now, in Magritte weather.

Barcelona, May 1986

Biography

1898 Birth of René François Ghislain Magritte, in the Belgian town of Lessines (Hainault), on 21 November. His father is Léopold Magritte, a tailor by trade, and his mother is Adeline Bertichamps, a milliner.

1900 The Magritte family settles in Gilly. On 29 June René's brother Raymond is born (died on 30 September 1970).

1902 Birth of Paul, René's second brother (died on 15 October 1975). The family changes its place of residence frequently, living successively in Châtelet, Charleroi and Brussels. René Magritte spends his holidays in Soignies, with an aunt.

1910 Attends his first painting course, in Châtelet.

1912 On 12 March, René Magritte's mother commits suicide by throwing herself into the river Sambre. Léopold Magritte moves to Charleroi with his children. René enters the *athénée* (secondary school) in this town

1913 At the Charleroi Fair, Magritte meets Georgette Berger (born on 22 February 1901), who is later to become his wife.

1915 Does his first works in the line of the Impressionists.

1916 Studies, until 1918, at the Académie des Beaux-Arts in Brussels, where his teachers are Combaz, Montald, and Van-Damme Sylva.

1918 The Magritte family moves to Brussels

1919 Magritte shares a studio with Pierre-Louis Flouquet, thanks to whom he discovers the works of the Cubists and the Futurists, as also the avant-garde artists of Antwerp. Contributes to the review *Au volant*, edited by Pierre Bourgeois. In December, participates in an exhibition of posters held in Brussels.

1920 In January has an exhibition with Pierre-Louis Flouquet at the Centre d'Art in Brussels. Meets E.L.T. Mesens, who is his brother Paul's piano teacher. In February attends a lecture given by Théo van Doesburg, a prominent member of the De Stijl movement. Meets Georgette Berger again, by pure chance, and becomes engaged to her. In October spends some days in Paris. In December participates, with five canvases, in the International Exhibition of Modern Art in Geneva.

1921 Does his military service in the infantry: at the Beverloo camp and later in Brussels. Does three portraits of his commanding officer.

1922 On 28 June, marries Georgette Berger, in Saint-Josseten-Noode, and does designs for the furniture of the apartment that is to be their home in Brussels. Earns his living by working as a designer in the Peeters-Lacroix wallpaper factory in Haren, where he works with Victor Servrancks. Together they write the essay *L'art pur: Défense de l'esthétique*. Magritte paints canvases that clearly betray Futurist and Cubist influences, also those of Léger and Delaunay.

1923 In April-May, participates in the group show organized by the review *Ça ira* in Antwerp, which includes works by Lissitsky and Moholy-Nagy, among others. Leaves the Peeters-Lacroix factory and sets up as a painter of commercial posters.

1924 Sells his first picture, a portrait of the singer Évelyne Brélia. Publishes some aphorisms in the October issue (No. 19) of Picabia's review *391*. Meets Marcel Lecomte and Camille Goemans.

1925 Decides to seek a new direction for his painting and abandons abstraction, as he is later to explain himself in a lecture entitled *La ligne de vie*, given in 1938. Paints *The Window*, of which he is to say in 1958 that it is his "first picture." In March is published the first (and only) number of the review *Œsophage*, founded by Magritte and E.L.T. Mesens. Through Marcel Lecomte, Magritte discovers French Surrealist poetry and the work of Giorgio de Chirico. Meets Paul Souris and Paul Nougé.

1926 Contributes to the review *Magie*, published by Mesens. Paints *The Lost Jockey*, which he is to consider his first Surrealist work. Now earns his living by doing publicity work for dress designers and furriers. Signs some Surrealist tracts, along with Goemans, Lecomte, Mesens, Nougé, and Souris.

1927 First one-man show, at the Galerie Le Centaure in Brussels (April-May, 49 oils and 12 *papiers collés*). Meets Louis Scutenaire, who becomes a close friend. In August moves into a house in Perreux-sur-Marne, where he is to remain for three years, and participates in the activities of the Surrealist group in Paris. His friends there are Goemans, now the owner of a gallery, Arp, Breton, Éluard, Miró, and later Dalí.

1928 Exhibition at the Galerie L'Époque (owned by Mesens) in Brussels. Publishes articles and drawings in the Belgian Surrealist review *Distances*, edited by Nougé. Participates in the Surrealist exhibition at the Galerie Goemans in Paris.

1929 Magritte publishes the five pamphlets *Le sens propre*, written in collaboration with Goemans. With his wife, spends the summer at Dalí's house in Cadaqués, where he meets Gala and Paul Éluard. In December, *La révolution surréaliste* publishes his article *Les mots et les images*, but his relationship with Breton is beginning to grow less friendly.

1930 Returns to Brussels. His financial problems are solved thanks to the sale, to Mesens, of eleven recent works. Is nevertheless obliged to continue working in publicity.

1931 One-man show (16 canvases) at the Salle Giso, Brussels.

1932 Joins the Belgian Communist party. Becomes friendly with Paul Colinet.

1933 One-man show at the Palais des Beaux-Arts in Brussels (May-June). Collaborates in the collective work *Violette Nozières*, published by Nicolas Flamel in Brussels.

1934 Paints *The Rape* for the cover of Breton's *Qu'est-ce que le surréalisme*, published by Henriquez in Brussels. Participates in the *Minotaure* exhibition, held in the Palais des Beaux-Arts, Brussels (May-June).

1936 First one-man show in New York, at the Julien Levy Gallery. One-man shows in the Palais des Beaux-Arts in Brussels and at the Esther Surrey Art Gallery in The Hague. In May participates in the "Exposition surréaliste

d'objets" at the Galerie Charles Ratton in Paris and in the International Surrealist Exhibition in London; also in the travelling exhibition "Fantastic Art, Dada, Surrealism," at the Museum of Modern Art in New York. Joins the Belgian Communist Party for the second time.

1937 In February and March spends some time at Edward James's house in London, where he gives a lecture on his work on the occasion of the exhibition "Young Belgian Artists."
In June travels to Japan, where his canvas *The Scarecrow* is included in the exhibition devoted to Surrealism. Is also represented in the exhibition of contemporary Belgian art held in Moscow and Leningrad. In July, makes the acquaintance of Marcel Mariën. In October, one-man show at the Julien Levy Gallery in New York. Does the cover for No. 10 of the review *Minotaure*. In December, presents 24 canvases at the exhibition "Three Surrealist Painters: René Magritte, Man Ray, Yves Tanguy," held in the Palais des Beaux-Arts in Brussels.

1938 One-man show at the Julien Levy Gallery in New York. Shows in the International Exhibition of Surrealism in Paris (January-February) and in the one held in Amsterdam (June). One-man show at the London Gallery, London (April-May). Gives a lecture entitled *La ligne de vie* at the Koninklijk Museum voor Schone Kunsten in Antwerp.

1939 One-man show at the Palais des Beaux-Arts, Brussels (May).

1940 Collaborates in *L'invention collective*, a review founded by Raoul Ubac (2 numbers: February and April). Leaves Belgium in May and, acompanied by his wife and by Irène and Louis Scutenaire, takes refuge in Carcassonne, where he remains for three months; there meets Joë Bousquet, Agui and Raoul Ubac, and is visited by Éluard.

1941 One-man show at the Galerie Dietrich in Brussels (January).

1943 Temporarily gives up his usual line in art and adopts the Impressionist technique; this is the so-called "Renoir period" of 1943 and 1944. In 1945 goes back to his initial line, but until 1947 is to go on painting canvases in the new style. In July, exhibits "Renoir paintings" at the Galerie Lou Cosyn in Brussels. In August, Marcel Mariën writes the first monograph on Magritte, which is followed in October by Paul Nougé's essay *René Magritte ou les images défendues*.

1944 One-man show at the Galerie Dietrich in Brussels (January).

1945 *The Red Model* (second version) illustrates the title page of the second edition of André Breton's *Le surréalisme et la peinture*, published by Brentano's in New York. In September, Magritte joins the Belgian Communist Party for the third time, only to leave it for good some months later. Organizes an exhibition entitled "Surrealism: Exhibition of pictures, drawings, photographs and writings," at the Galerie des Éditions La Boétie in Brussels (December 1945-January 1946)

1946 In collaboration with Mariën, writes the subversive lampoons *L'imbécile, L'emmerdeur,* and *L'enculeur,* published anonymously. The latter two confiscated by the police. Does 12 drawings to illustrate Éluard's book *Les nécessités de la vie et les conséquences des rêves,* preceded by *Exemples.* Publication (in October) of Manifesto No. 1 of *Surréalisme en plein soleil,* entitled *L'expérience continue* and signed by Bousquet, Magritte, Mariën, Paul Nougé, Scutenaire, and Wergifosse. This text meets with an unfavorable reception from Breton and is to lead to a further deterioration in the latter's relations with Magritte. One-man show at the Galerie Dietrich in Brussels (November-December). Magritte draws the cover for a special number of the New York review *View,* devoted to "Surrealism in Belgium" and organized by Paul Nougé.

1947 One-man show at the Société Royale des Beaux-Arts in Verviers (January-February), which later (April) goes on to the Hugo Gallery in New York (one of whose owners, Alexandre Iolas, is to become the artist's dealer in the United States the following year), and (May-June) to the Galerie Lou Cosyn in Brussels. Publication of Louis Scutenaire's monograph on Magritte.

1948 One-man shows at the Galerie Dietrich in Brussels (January-February), the Hugo Gallery in New York (May), the Galerie du Faubourg in Paris (May-June: Magritte's first exhibition in this city) and the Copley Gallery in Hollywood (September). Participates in the Venice Biennale (June-September). Goes through a Fauvist period, also known as his *période vache,* but very soon gives up this style.

1949 One-man show at the Galerie Lou Cosyn in Brussels (February).

1950 One-man show in Charleroi (April-May).

1951 One-man shows at the Hugo Gallery in New York and at the Galerie Dietrich in Brussels (March-April). Receives an official commission to paint the ceiling of the Théâtre Royal des Galeries in Brussels.

1952 Exhibition, with Paul Delvaux, at the Municipal Casino of Knokke-le-Zoute. Founds (October) and edits *La carte d'après nature,* which is published in postcard format (the tenth, and last, number is dated in April 1956).

1953 One-man shows at the Galleria dell'Obelisco in Rome (January) and the Alexandre Iolas Gallery in New York (March-April). Composes 8 canvases which are intended, after enlargement, to decorate the walls of the gaming room in the Municipal Casino of Knokke-le-Zoute: *The Enchanted Realm.* The vernissage is held in July

1954 One-man show at the Sidney Janis Gallery in New York (21 paintings with inscriptions). First retrospective exhibition, in the Palais des Beaux-Arts in Brussels, organized by E.L.T. Mesens.

1955 Participates in the Venice Biennale.

1956 Retrospective exhibition in the Palais des Beaux-Arts in Charleroi. Awarded the Guggenheim Prize.

1957 One-man show at the Alexandre Iolas Gallery in New York. Does the mural paintings entitled *The Ignorant Fairy* for the Palais des Beaux-Arts in Charleroi.

1958 One-man show at the Alexandre Iolas Gallery in New York and the Galerie Cahiers d'art in Paris.

1959 One-man show at the Alexandre Iolas Gallery in New York (March). Retrospective exhibition in the Museum of Ixelles (April-May). Ten drawings by Magritte illustrate Mesens' book *Poèmes 1923-1958,* published by Le Terrain vague in Paris.

1960 Exhibition at the Galerie Rive Droit in Paris (February-March). Spends some time in Paris, where he visits Breton (September). In October, Suzi Gablik stays at Magritte's house and begins work on the monograph on the painter which is to be published in London in 1970 and in Paris in 1978. Retrospective exhibitions in the Musée des Beaux-Arts in Liège (October-November), the Museum for

Contemporary Arts in Dallas and the Museum of Fine Arts in Houston (December 1960-March 1961).

1961 Contributes to the review *Rhétorique*, edited by André Bosmans (13 issues: May 1961-February 1966). Does *The Mysterious Barricades*, a mural painting for the Congress Hall of the Albertina (Albert I Royal Library) in Brussels. Retrospective exhibitions at the Grosvenor Gallery and the Obelisk Gallery in London (September-October).

1962 One-man shows at the Alexandre Iolas Gallery in New York (May) and the Galleria Schwarz in Milan (December; later, in January 1963, at the Galleria L'Attico in Rome). Retrospective exhibition in the Municipal Casino of Knokke-le-Zoute (July-August) and the Walker Art Center, Minneapolis (September-October).

1963 One-man show at the Galerie Alexandre Iolas in Geneva (October).

1964 One-man show at the Galerie Alexandre Iolas in Paris (November-December), the same show being presented at the Alexandre Iolas Gallery in New York in January-February 1965. In the December issue of *Mercure de France*, Henri Michaux publishes his essay on Magritte entitled *En rêvant à partir de peintures énigmatiques*. Exhibition in Little Rock, Arkansas.

1965 Holiday in Ischia, after spending some days in Rome. In June undergoes a medical examination. Publication in Brussels of Patrick Waldberg's monograph. Retrospective exhibition at the Museum of Modern Art in New York (December), on which occasion Magritte visits the United States for the first time; this exhibition is later presented at Brandeis University, in Chicago, in Berkeley and in Pasadena. Publication of James Thrall Sobey's monograph in New York.

1966 In April, Georgette and René Magritte visit Israel; after that, in June, they spend some time in Cannes and Montecatini with Scutenaire and Irène Hamoir.

1967 One-man show at the Galerie Alexandre Iolas in Paris (January-February). In June, visits Italy, where he does the wax figures for sculptures which are to be cast in bronze after his death. On 15 August dies at his home in Brussels. On 4 August the vernissage of a retrospective exhibition of his works had taken place at the Boymans-van Beuningen Museum in Rotterdam.

1968 Figures in the group show "Dada, Surrealism and their Heritage," held at the Museum of Modern Art in New York.

1969 Individual exhibitions of his work at the Tate Gallery in London, the Kestner Gesellschaft in Hanover, and the Kunsthaus in Zürich.

1971 Exhibitions at the National Museum of Modern Art in Tokyo and at the Museum of Modern Art in Kyoto.

1972 Figures in the exhibition entitled "Painters of the Imaginary: Belgian Symbolists and Surrealists," held at the Grand Palais in Paris and the Musées Royaux des Beaux-Arts in Brussels.

1976 Exhibition "Secret Affinities: Words and Images by René Magritte" at the Institute for the Arts, Rice University, Houston (1976-1977). Exhibition "The fidelity of images: René Magritte, cinema and photography" at the Musées Royaux des Beaux-Arts in Brussels.

1977 Exhibition "Magritte" at the Centre d'Arts Plastiques Contemporains in Bordeaux. Publication of *René Magritte: Signes et images*, by Harry Torczyner and Bella Bessard (Draeger/Vilo, Paris).

1978-79 Retrospective exhibition in the Palais des Beaux-Arts in Brussels (27 October-21 December 1978) and at the Centre Georges Pompidou in Paris (19 January-9 April 1979)

1979 Exhibition "Magritte" at the Galerie Isy Brachot in Brussels.

1982-83 Exhibition "René Magritte and Surrealism in Belgium" in the Musées Royaux des Beaux-Arts de Belgique, Brussels (24 September-5 December 1982). Figures in the exhibition "Paul Éluard and his painter friends," held at the Centre Georges Pompidou in Paris (4 November 1982-17 January 1983).

1985 Figures in the exhibition "Surrealism/Realism: The Galerie Isy Brachot (Brussels/Paris) in Barcelona," at the Galeria Maeght in Barcelona (December 1985-January 1986).

1986 Is included in the exhibitions "The planet gone mad. Surrealism. Dispersion and influences 1938-1947," at the Centre de la Vieille Charité, Marseilles (12 April-30 June), and "The Surrealist adventure with André Breton at its center," at the Galerie Artcurial in Paris (May-July).

Bibliography

1. Writings by René Magritte

Manifestes et autres écrits. Foreword by Marcel Mariën. Les lèvres nues, Brussels, 1972.

"Lettres surréalistes (1924-1940)," compiled and annotated by Marcel Mariën, in *Le fait accompli* (Brussels), 81-85, May-August 1973.

"Lettres à Paul Nougé," *Le fait accompli* (Brussels), 127-129, November 1975.

Quatre-vingt-deux lettres de René Magritte à Mirabelle Dors et Maurice Rapin. Presses du C.B.E., Paris, 1976.

La destination: Lettres à Marcel Mariën (1937-1962). Les lèvres nues, Brussels, 1977.

"Deux écrits inédits," in *Cahiers du Musée national d'art moderne*, Paris, No. 1, 1979.

Écrits complets, edited by André Blavier. Flammarion, Paris, 1979 (In "Textes/Flammarion," a collection directed by Bernard Noël).

2. General works

BIRO, Adam & PASSERON, René (Editors): *Dictionnaire général du surréalisme et de ses environs.* PUF, Paris, 1982.

BUSSY, Christian: *Anthologie du surréalisme en Belgique.* Gallimard, Paris, 1972.

MARIËN, Marcel: *L'activité surréaliste en Belgique.* Lebeer Hossmann, Brussels, 1979.

VOVELLE, José: *Le surréalisme en Belgique.* André de Rache, Brussels, 1972.

3. Works on Magritte

BLAVIER, André: *Ceci n'est pas une pipe: Contribution furtive à l'étude d'un tableau de Magritte.* Temps mêlés, Verviers, 1973 ("Opinions et documents," I).

DOPAGNE, J.: *Magritte.* Hazan, Paris, 1977.

FOUCAULT, Michel: *Ceci n'est pas une pipe.* Fata Morgana, Montpellier, 1973 (published along with the article of the same title which appeared in *Cahiers du chemin* (Paris) in January 1968.

GABLIK, Suzi: *Magritte.* Thames & Hudson, London, 1977; German translation published by Praeger, Munich, 1971; French translation published by Cosmos Monographies, Brussels, 1978.

HAMMACHER, A.M.: *Magritte.* Abrams, New York, 1974; French translation published by Cercle d'Art, Paris, 1974.

LEBEL, Robert: *Magritte: Peintures.* Hazan, Paris, 1969 (in the collection "Petite encyclopédie de l'art," 95).

MARIËN, Marcel: *Magritte.* Les auteurs associés, Brussels, 1943.

MICHAUX, Henri: *En rêvant à partir de peintures énigmatiques.* Fata Morgana, Montpellier, 1972 (published along with the article of the same title which appeared in *Mercure de France* (Paris) in December 1974.

NOËL, Bernard: *Magritte.* Flammarion, Paris, 1976.

NOUGÉ, Paul: *René Magritte ou les images défendues.* Les auteurs associés, Brussels, 1943.

NOUGÉ, Paul: *Histoire de ne pas rire.* Les lèvres nues, Brussels, 1956.

PAQUET, M.: *Magritte ou l'éclipse de l'être.* Éd. de la différence, Paris, 1982.

PASSERON, René: *René Magritte.* Filipacchi/Odège, Paris, 1970; second edition, 1972.

ROBBE-GRILLET, Alain: *René Magritte: La Belle captive* (novel). Cosmos, Brussels, 1975.

ROBERTS-JONES, Philippe: *Magritte poète visible.* Laconti, Brussels, 1972.

ROQUE, Georges: *Ceci n'est pas un Magritte: Essai sur Magritte et la publicité.* Flammarion, Paris, 1983.

SCHIEBLER, Ralf: *Die Kunsttheorie René Magrittes.* Hanser, Munich/Vienna, 1981.

SCHNEEDE, Uwe M.: *René Magritte: Leben und Werk.* DuMont-Schauberg, Cologne, 1975 (in the collection "Kunstaschenbücher", No. 4).

SCUTENAIRE, Louis: *Avec Magritte.* Lebeer Hossmann, Brussels, 1977.

SOBY, James Thrall: *René Magritte.* The Museum of Modern Art, New York, 1965.

SYLVESTER, David: *Magritte.* Praeger, New York/Washington, 1969.

TORCZYNER, Harry & BESSARD, Bella: *René Magritte: Signes et images.* Draeger/Vilo, Paris, 1977; Draeger, Paris, 1982.

WALDBERG, Patrick: *René Magritte.* With a general bibliography compiled by André Blavier. De Rache, Brussels, 1965.

4. Articles on Magritte

BOUNOURE, V.: "Le thème de la contradiction chez Magritte," *L'Oeil*, 206-207, Paris, February-March 1972.

BUTOR, Michel: "Magritte et les mots," *Les lettres françaises*, Paris, 13 November 1968.

CALAS, E.: "Magritte's Inaccessible Woman," *Art-Forum*, XVII (7), New York, March 1979.

HELD, R.F.: "René Magritte ou le prestidigitateur illusionniste," in *L'Oeil du psychanalyste. Surréalisme et surréalité*, Payot, Paris, 1973.

LASCAULT, Gilbert: "Explorations dans la planète Magritte," *Cahiers du Musée national d'art moderne*, 1, Paris, 1979.

LEBEL, Robert: "Avant et après Magritte," *L'Oeil*, 159, Paris, March 1968.

NOUGÉ, Paul: "Pour illustrer Magritte," *Le fait accompli*, 34-35, Brussels, April 1970.

SHATTUCK, A.: "This is not René Magritte," *Art-Forum*, VI September 1966.

SOURIS, André: "Paul Nougé et ses complices," in *Entretiens sur le surréalisme sous la direction de Ferdinand Alquié*, Mouton, Paris/The Hague, 1968.

5. Exhibition catalogues

"Le mystère de la réalité," Boymans-van Beuningen Museum, Rotterdam, 1967. Text by J. Dypreau.

"Magritte," The Tate Gallery, London, 1969. Text by D. Sylvester.

"René Magritte," Kestner Gesellschaft, Hanover, 1969. Texts by V. Kahmen, W. Schmied, etc.

"La fidelité des images: René Magritte, le cinématographe et la photographie," Musées Royaux des Beaux-Arts, Brussels, 1976.

"Magritte," Centre d'Arts Plastiques Contemporains, Bordeaux, 1977. Texts by G. Roque, M. Mariën, J. Vovelle, S. Gablik, J.-M. Pontevia.

"Rétrospective Magritte," Palais des Beaux-Arts, Brussels, and Musée National d'Art Moderne, Centre Georges Pompidou, Paris, 1978-79. Texts by Pontus Hulten, Jean-Maurice Dehousse, Francis de Luffe, Louis Scutenaire, Jean Clair, David Sylvester.

"Magritte," Galerie Isy Brachot, Brussels, 1979. Texts by E. Kornelis and A. de Knop..

"René Magritte et le surréalisme en Belgique," Musées Royaux des Beaux-Arts, Brussels, 1982. Texts by Philippe Moureaux, "Elle et Lui," Marcel Mariën, Marc Dachy, Philippe Roberts-Jones.

1. *Young Woman*. 1924.
 Oil on canvas, 55×40 cm.
 Mme. René Magritte Collection, Brussels.

2. *The Bather*. 1923.
 Oil on canvas, 50×100 cm.
 M. and Mme. Berger-Hoyez Collection, Brussels.

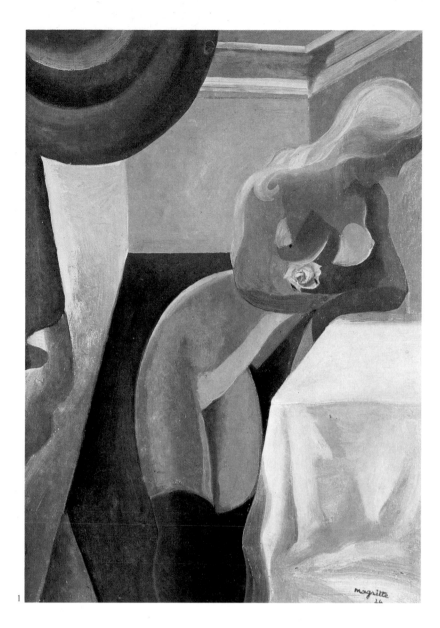

1

2

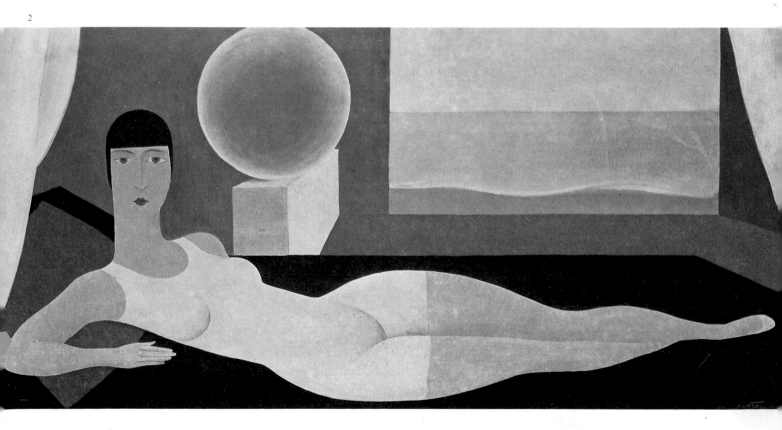

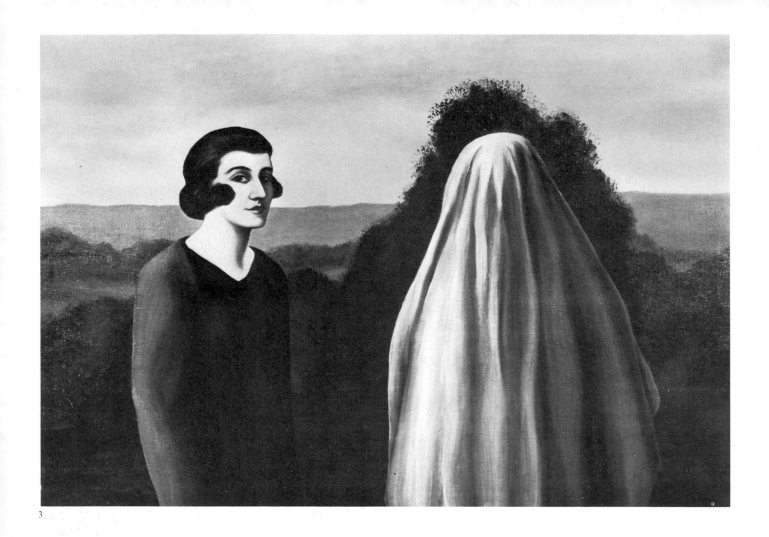

3

4

5

3. *The Invention of Life*. 1926.
 Oil on canvas, 80 × 120 cm.
 M. and Mme. Louis Scutenaire Collection, Brussels.

4. *The Heart of the Matter*. 1927.
 Oil on canvas, 116 × 81 cm.
 M. and Mme. Marcel Mabille Collection, Rhode-St-Genèse, Belgium.

5. *In the Land of Night*. 1928.
 Oil on canvas, 186 × 105 cm.
 William N. Copley Collection, New York.

6. *Discovery*. 1927.
 Oil on canvas, 65 × 50 cm.
 M. and Mme. Louis Scutenaire Collection, Brussels.

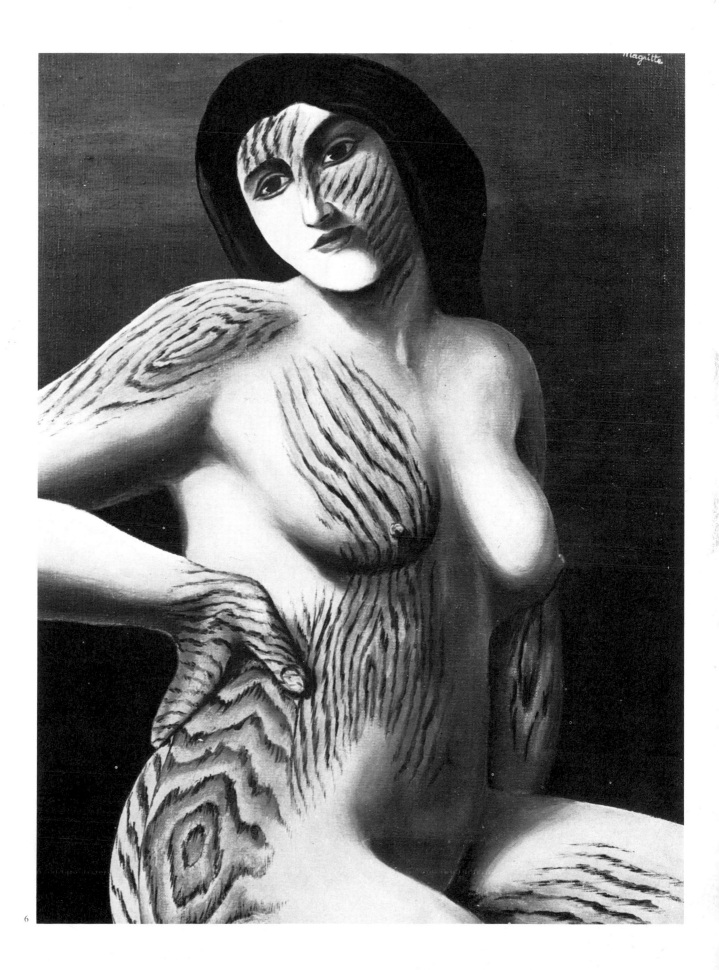

6

7. *The Comic Spirit*. 1927.
 Oil on canvas, 75×60 cm.
 M. and Mme. Berger-Hoyez Collection, Brussels.

8. *The Oasis*. 1925-27.
 Oil on canvas, 75×65 cm.
 Mme. J. Van Parys Collection, Brussels.

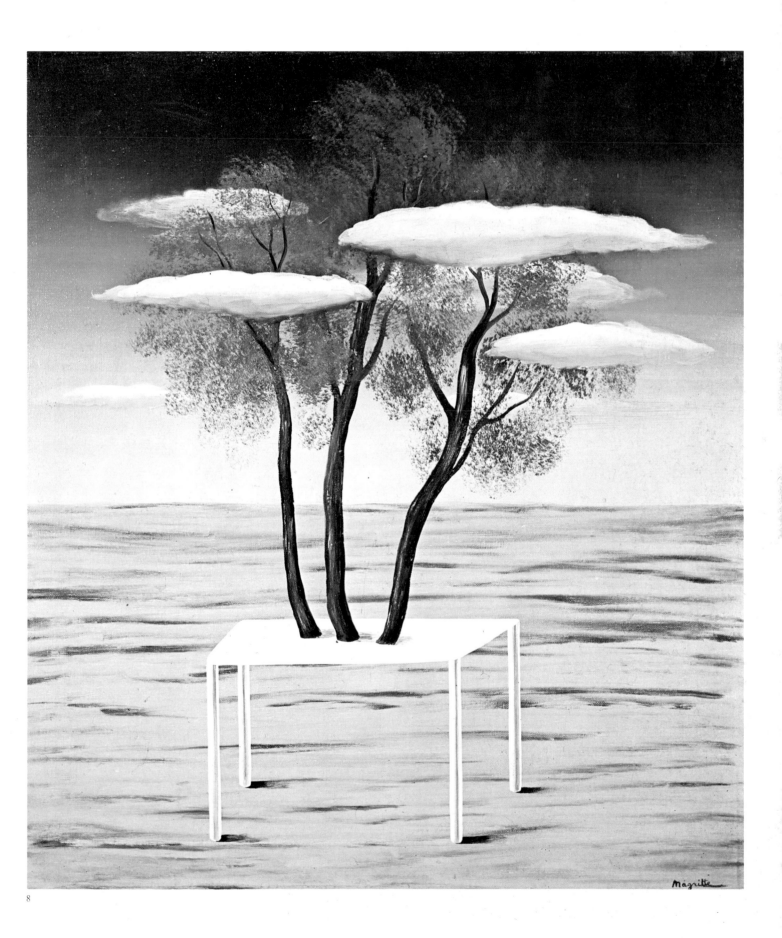

9

9. *Countryside III.* 1927.
 Oil on canvas, 73.5 × 54 cm.
 Isy Brachot Collection, Brussels.

10. *The Familiar Objects.* 1928.
 Oil on canvas, 81 × 116 cm.
 Private collection, Brussels.

11. *The Lovers.* 1928.
 Oil on canvas, 54 × 74 cm.
 Richard S. Zeisler Collection, New York.

12. *The Lovers.* 1928.
 Oil on canvas, 54 × 73 cm.
 Mme. J. Van Parys Collection, Brussels.

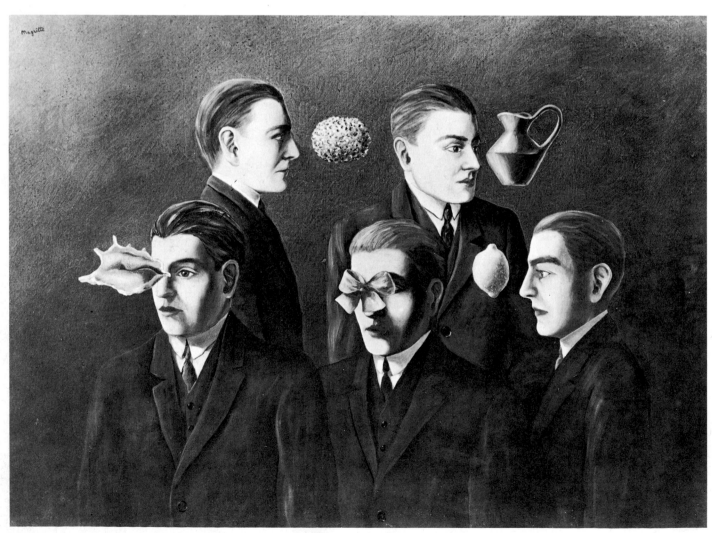

10

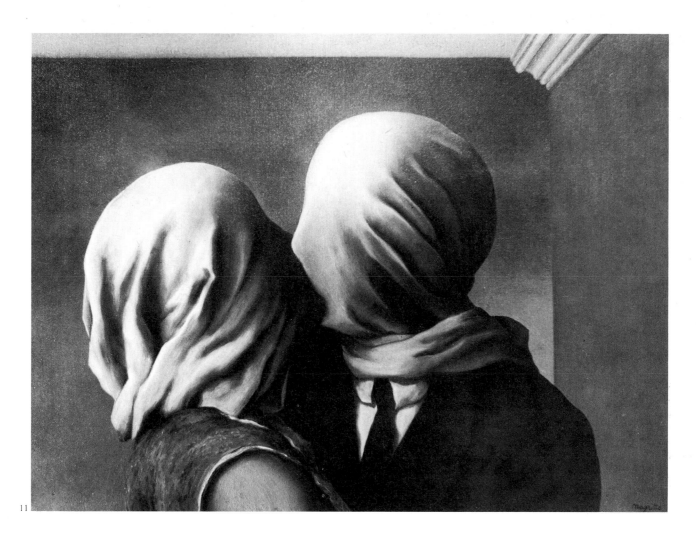

11

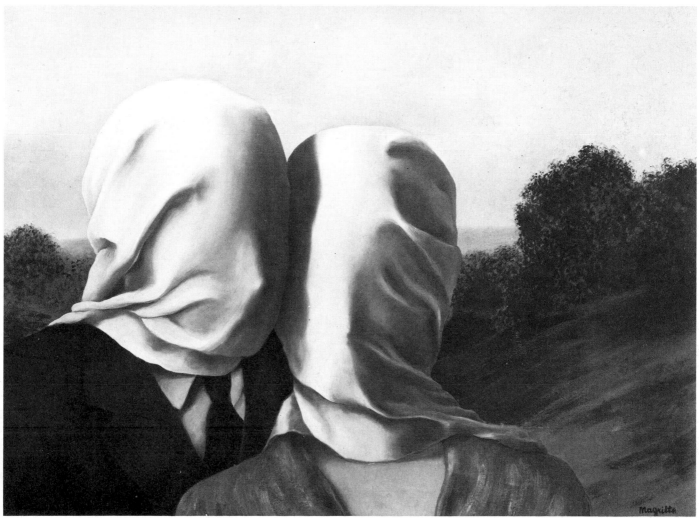

12

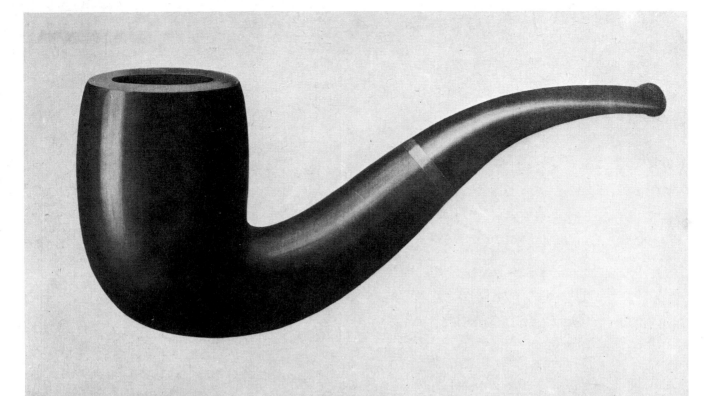

Ceci n'est pas une pipe.

Magritte 13

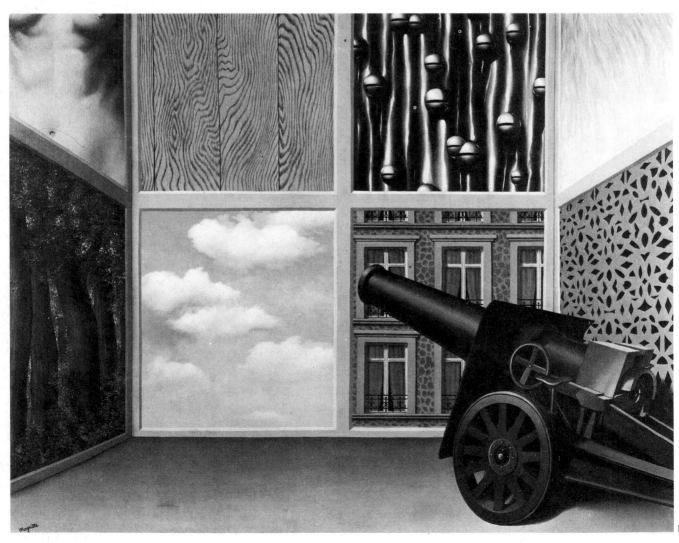

14

13. *This is Not a Pipe*. 1928-29.
 Oil on canvas, 59 × 80 cm.
 William N. Copley Collection, New York.

14. *On the Threshold of Liberty*. 1929.
 Oil on canvas, 114.5 × 146.5 cm.
 Boymans-van Beuningen Museum, Rotterdam.

15. *The Voice of the Winds*. 1928.
 Oil on canvas, 65 × 50 cm.
 Private collection, United States.

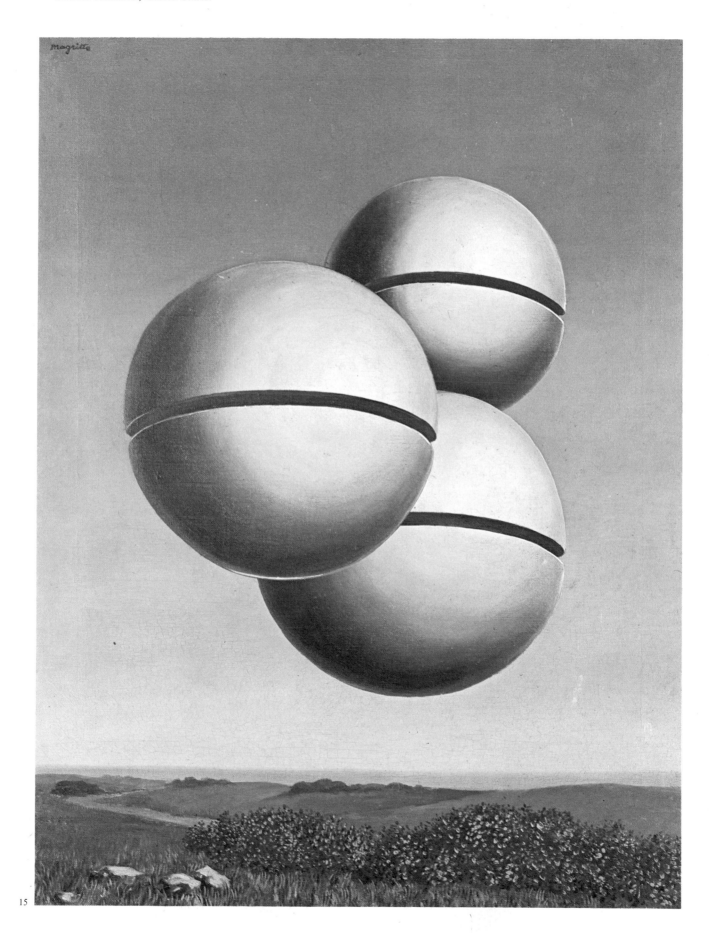

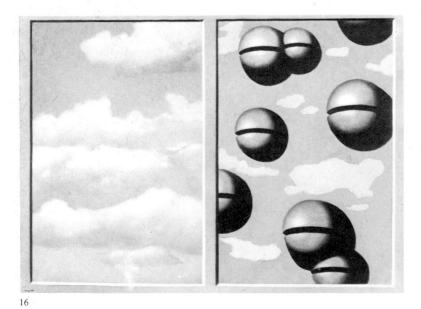

16

16. *Pink Bells, Tattered Skies*. 1930.
Oil on canvas, 73 × 100 cm.
Baron Joseph-Berthold Urvater Collection, Paris.

17. *The Annunciation*. 1930.
Oil on canvas, 114 × 146 cm.
Private collection, Brussels.

18. *The End of Contemplation*. 1930.
Oil on canvas, 79 × 115 cm.
Private collection, Belgium.

19. *Threatening Weather*. 1931-32.
Oil on canvas, 54 × 73 cm.
Roland Penrose Collection, London.

17

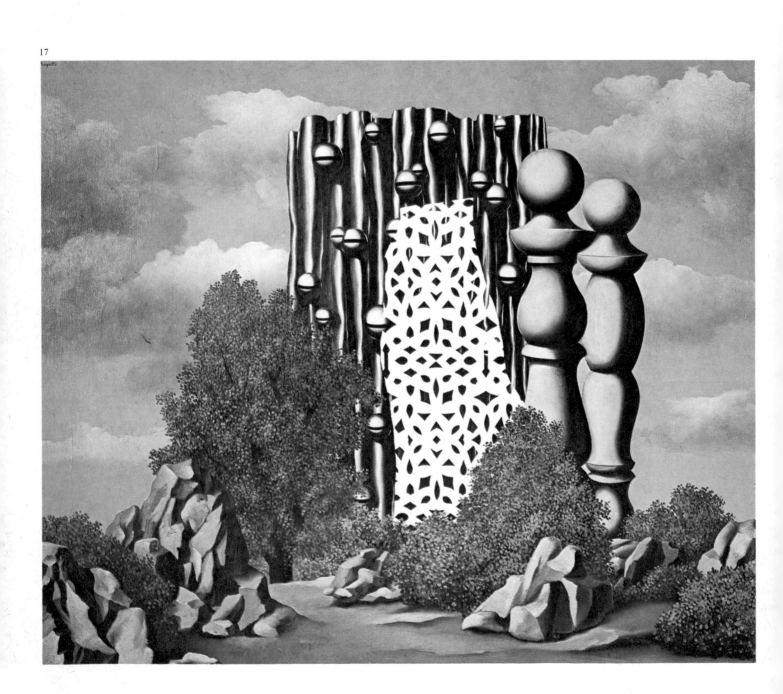

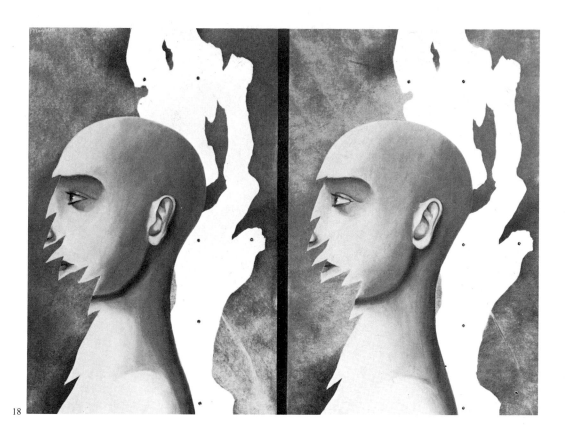

18

19

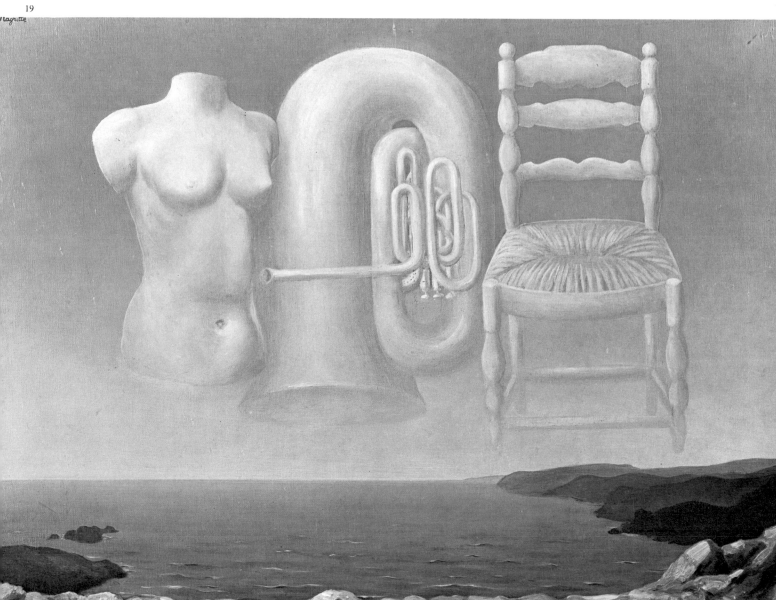

20

20. *Free Union*. 1933.
 Oil on canvas, 58.5 × 80 cm.
 William N. Copley Collection, New York.

21. *Metamorphosis of the Object*. 1933.
 (Study for an ashtray)
 Gouache, 10 × 10 cm.
 Private collection, Brussels.

22. *The Unexpected Answer*. 1933.
 Oil on canvas, 82 × 54.5 cm.
 Musées Royaux des Beaux-Arts, Brussels.

21

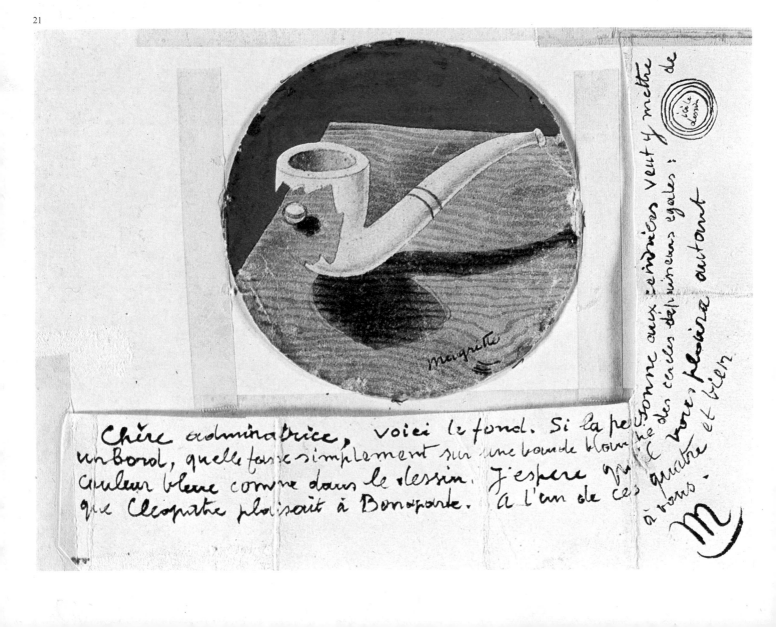

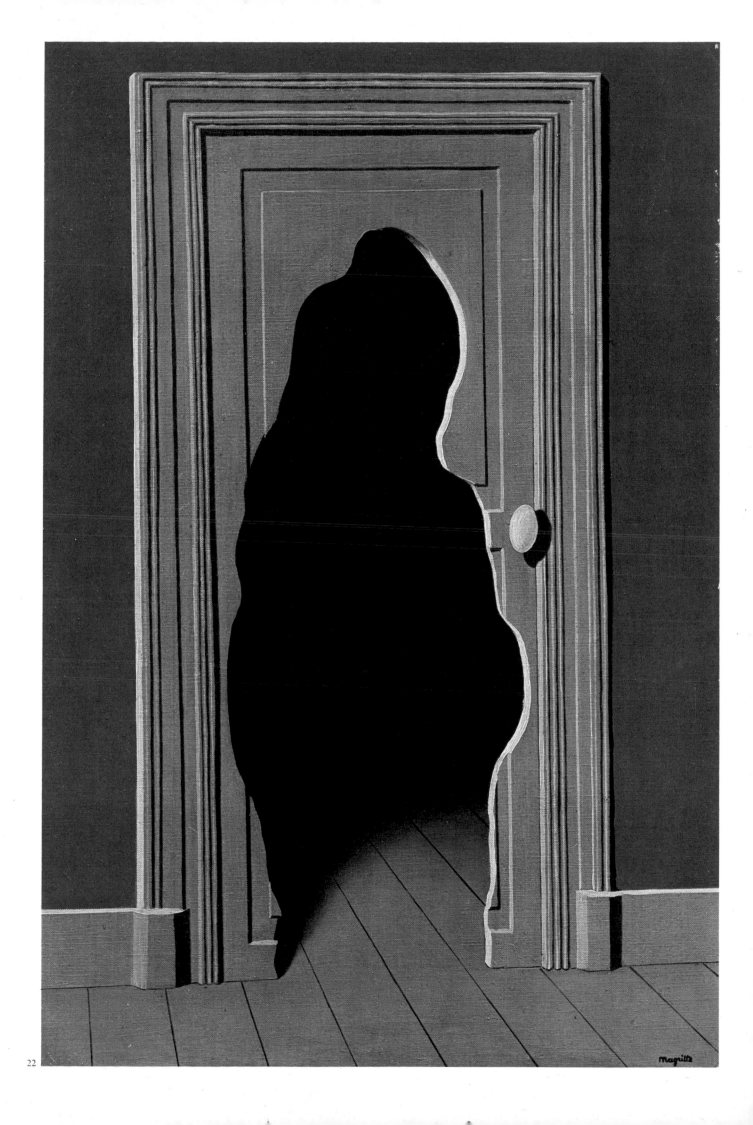

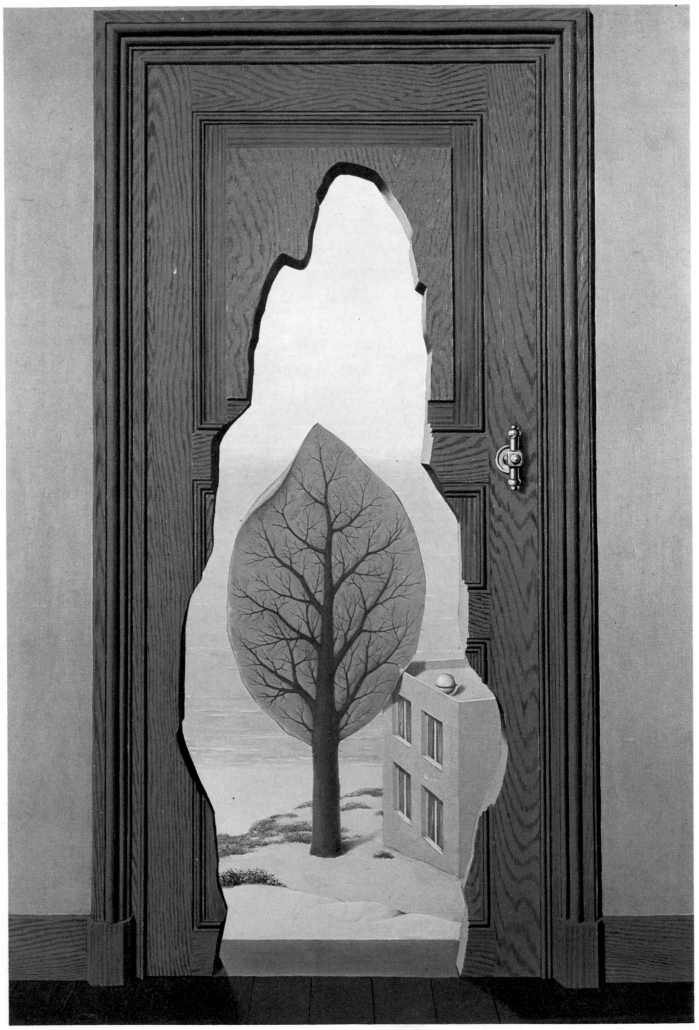

23. *Amorous Perspective*. 1935.
 Oil on canvas, 116 × 81 cm.
 Private collection, Brussels.

24. *Homage to Alphonse Allais*.
 Oil on canvas, 28 × 36.5 cm.
 Harry G. Sundheim Collection, Chicago.

25. *The Collective Invention*. 1934.
 Oil on canvas, 35 × 113 cm.
 Private collection, Belgium.

24

25

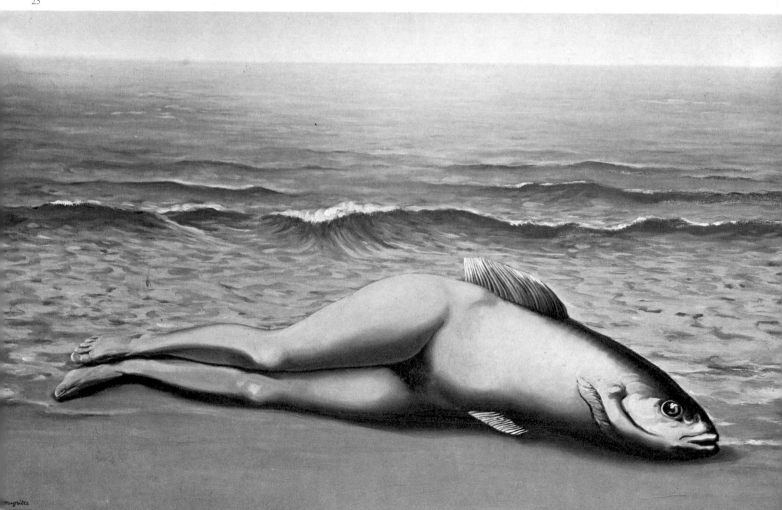

26. *Napoleon's Mask*. c. 1935.
 Painted plaster, 32 cm. in height.
 Collection of the Edward James Foundation, Chichester, Sussex.

27. *The Healer*. 1936.
 Gouache, 46×30 cm.
 Private collection, Brussels.

28. *The Healer*. 1937.
 Oil on canvas, 92×65 cm.
 Baron Joseph-Berthold Urvater Collection, Paris.

29. *Clairvoyance*. 1936.
 Oil on canvas.
 Private collection, Belgium.

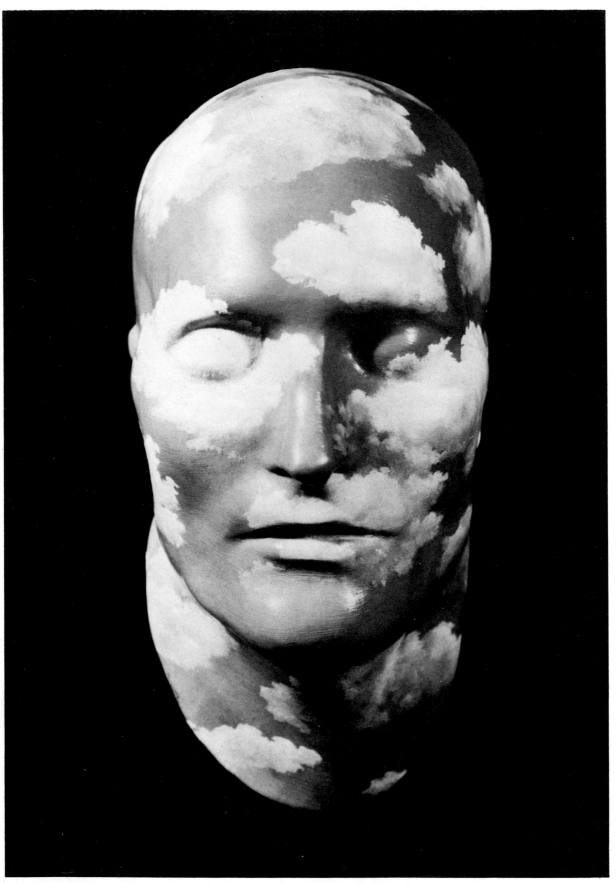

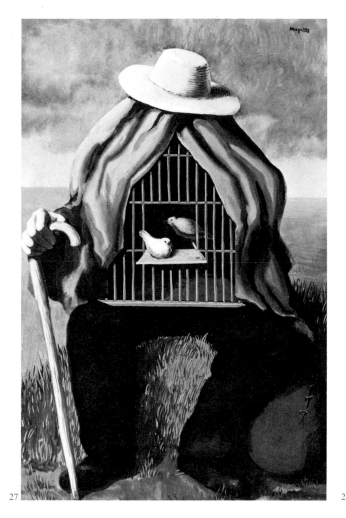

27

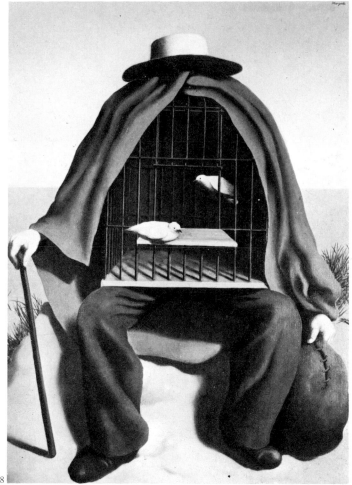

28

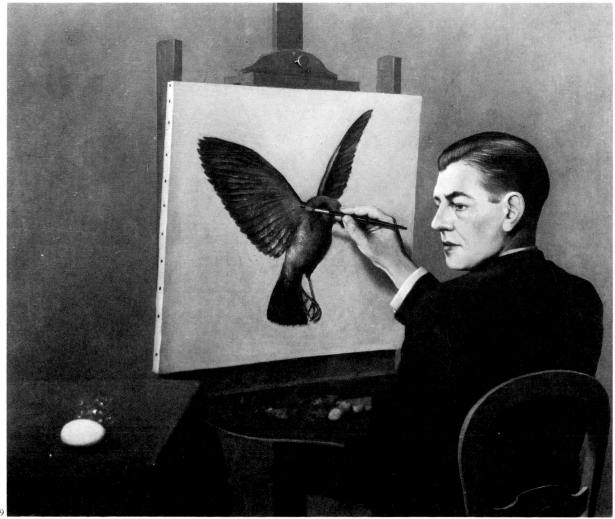

29

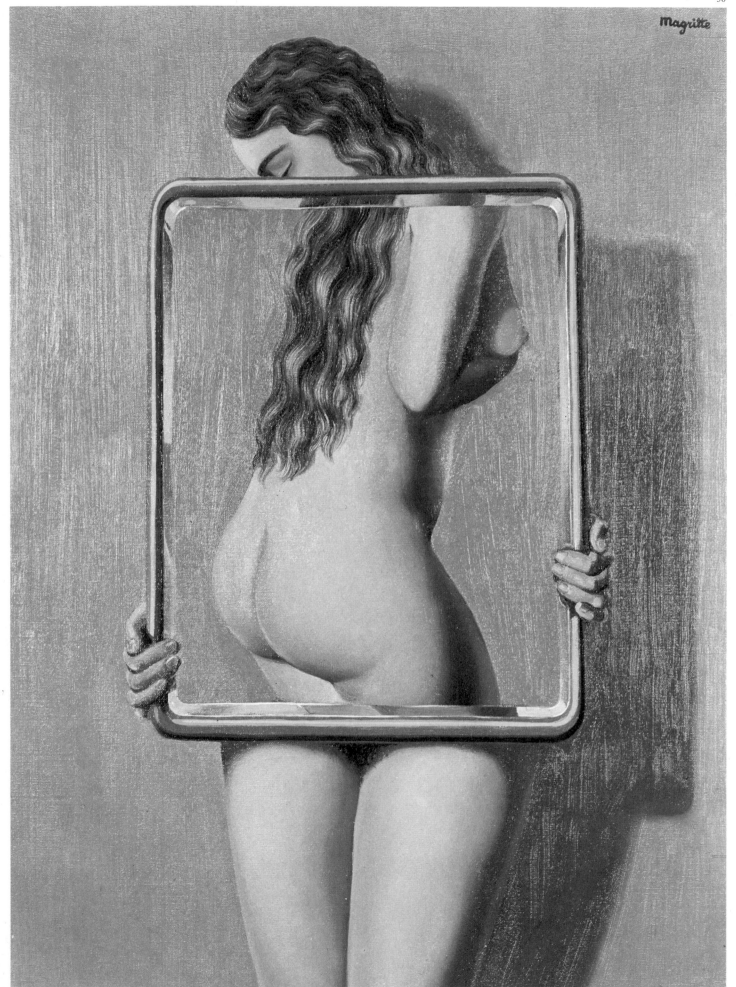

30. *Dangerous Relationships*. 1936.
 Oil on canvas, 72×64 cm.
 Private collection, Calvados.

31. *Black Magic*. 1935.
 Oil on canvas, 80×60 cm.
 Mme. René Magritte Collection, Brussels.

32. *The Traveller*. 1937.
 Oil on canvas, 55×66 cm.
 Private collection, Brussels.

31

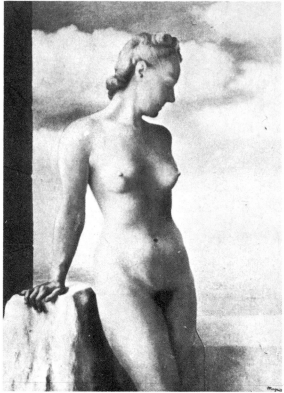

32

33. *Passionflower*. 1936.
 Oil on canvas, 45 × 55 cm.
 M. and Mme. Louis Scutenaire Collection, Brussels.

34. *Meditation*. 1937.
 Oil on canvas, 34 × 39 cm.
 Collection of the Edward James Foundation, Chichester, Sussex.

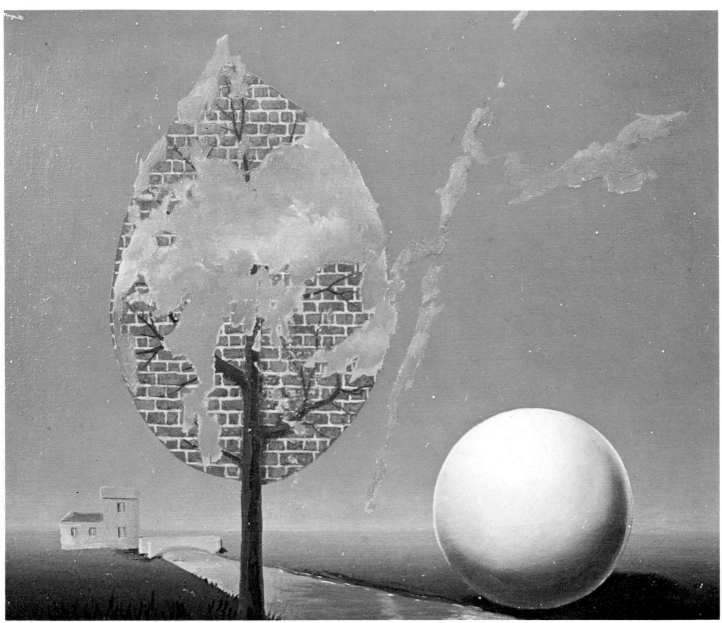

33

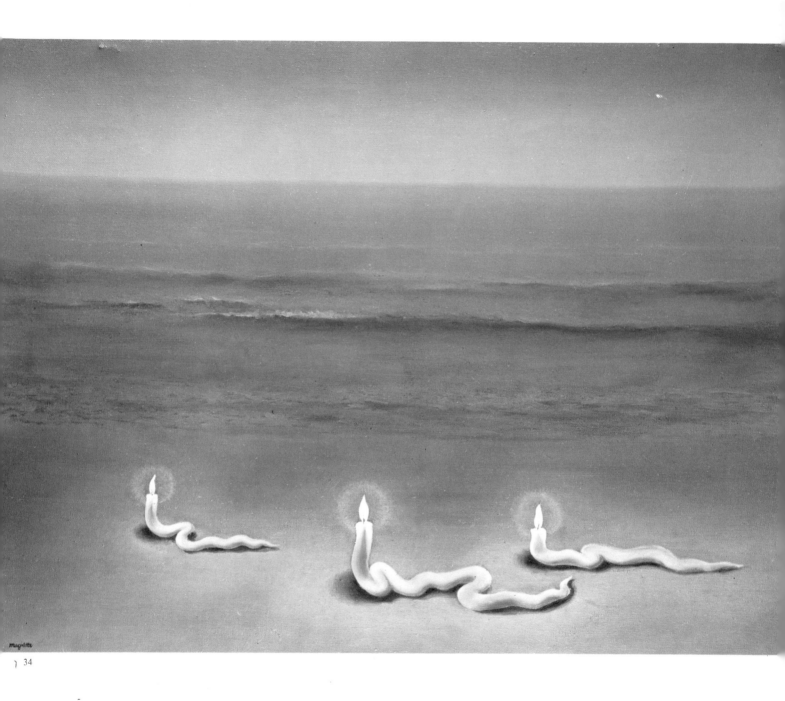

35. *The Human Condition*. 1934.
 Oil on canvas, 100×81 cm.
 Private collection, Paris.

36. *The Sentimental Colloquy* (The Guides). 1937.
 Sanguine on paper, 36×46 cm.
 Jean-Louis Merckx Collection, Brussels.

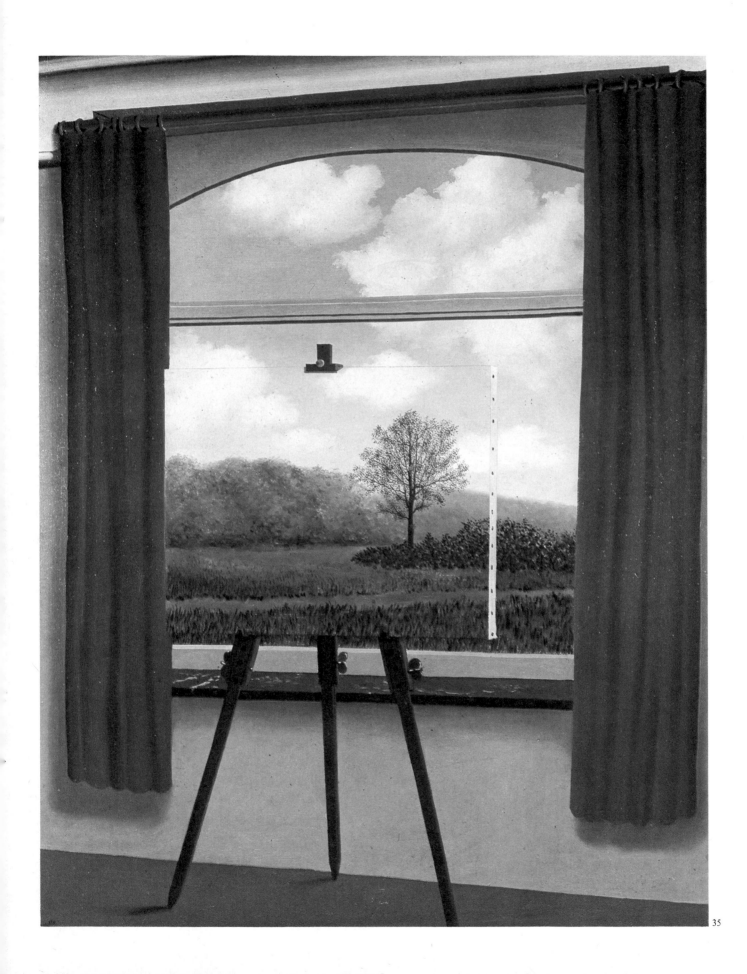

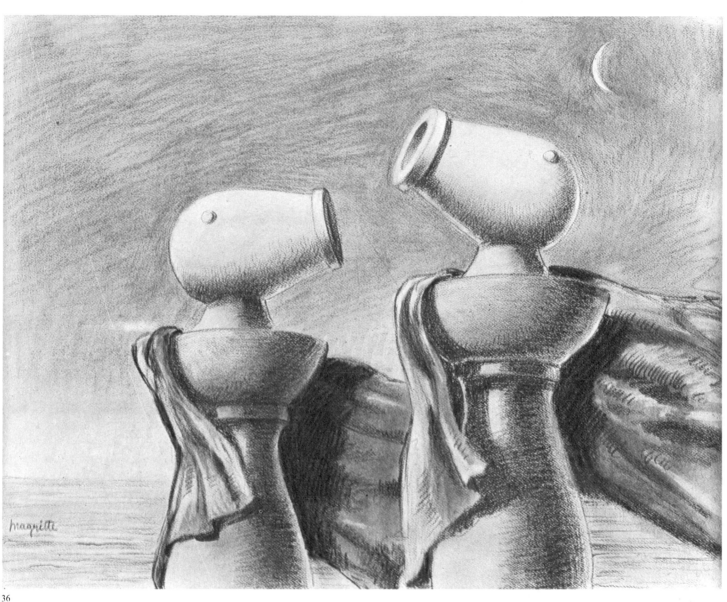

36

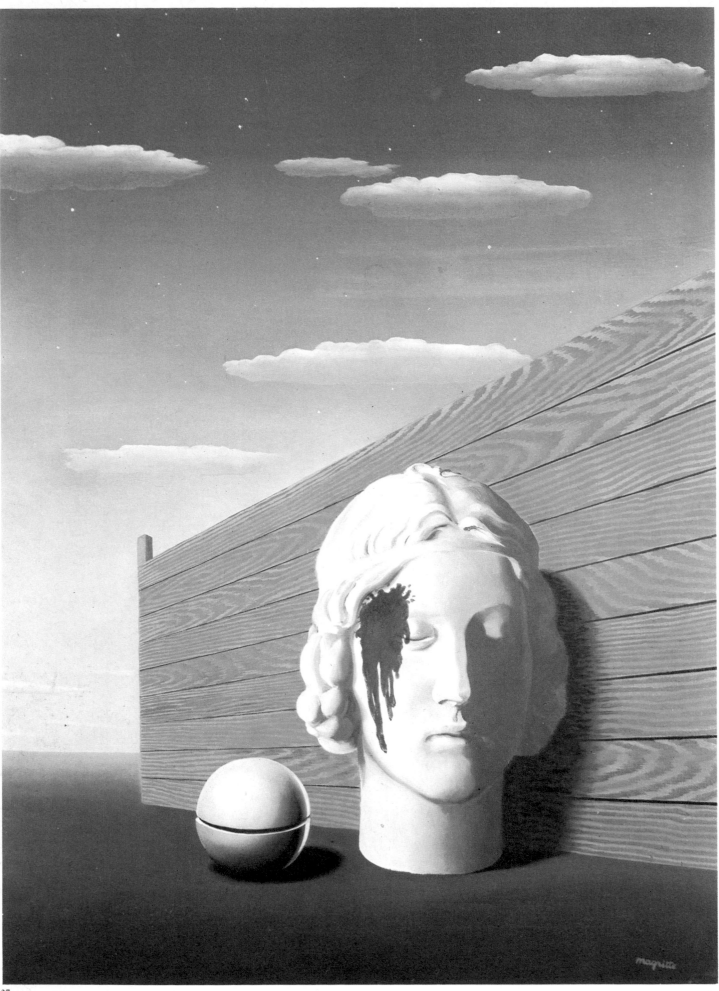

37. *Memory*. 1938.
 Oil on canvas, 72.5×54 cm.
 Collection of the Menil Foundation, Houston.

38. *The Clouds*. 1939.
 Gouache, 34.3×33 cm.
 Private collection, Belgium.

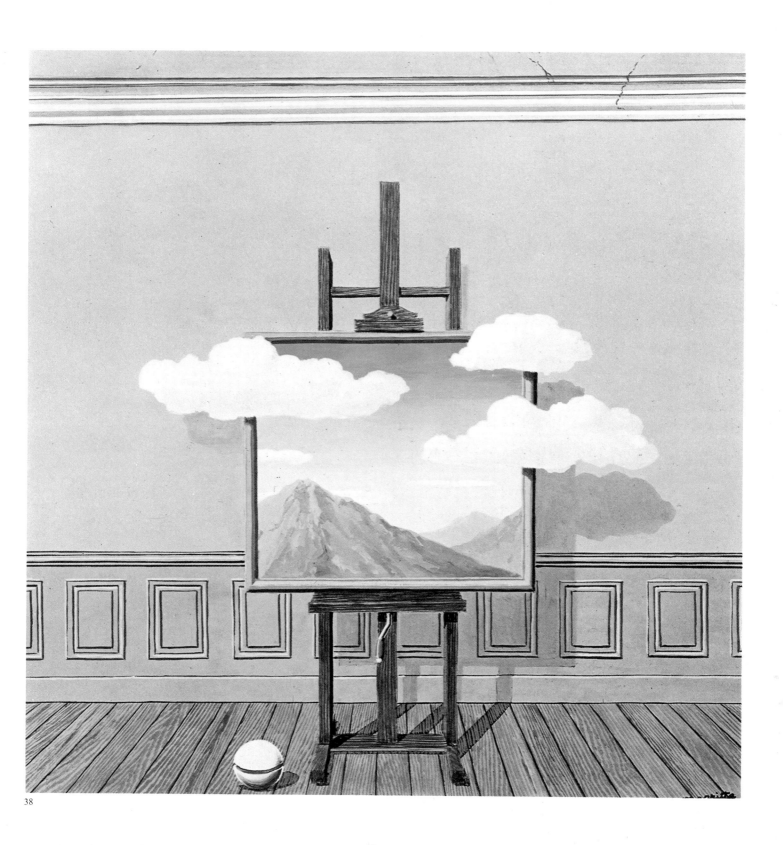

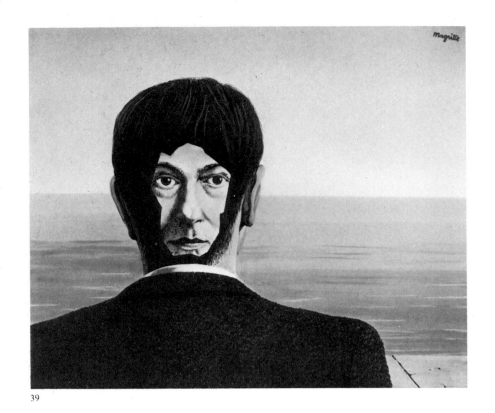

39

40

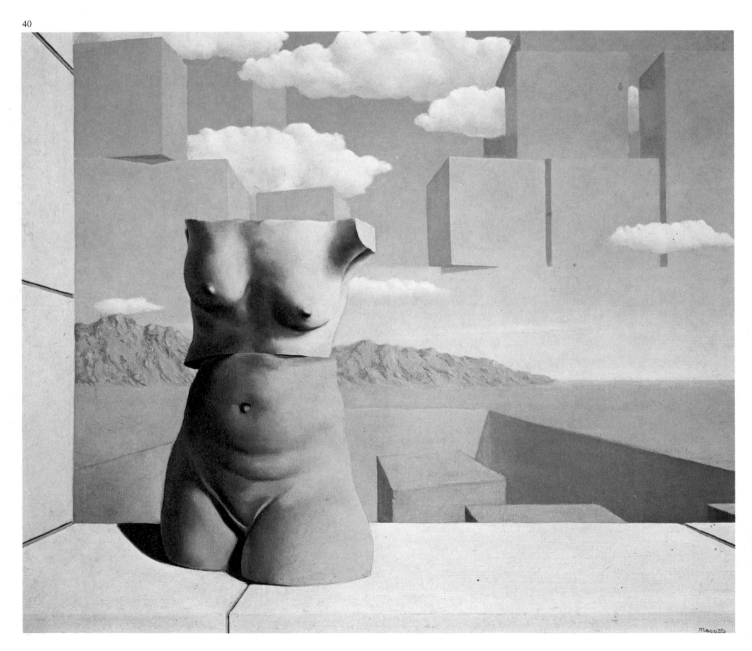

39. *The Glass House*. 1939.
 Gouache, 35 × 40 cm.
 Collection of the Edward James Foundation, Chichester, Sussex.

40. *The Progress of Summer*. 1938.
 Oil on canvas, 60 × 73 cm.
 Private collection, Paris.

41. *Time Transfixed*. 1939.
 Oil on canvas, 146 × 98.5 cm.
 The Art Institute of Chicago, Chicago.

42. *Poison*. 1939.
 Gouache, 35 × 40 cm.
 Collection of the Edward James Foundation, Chichester, Sussex.

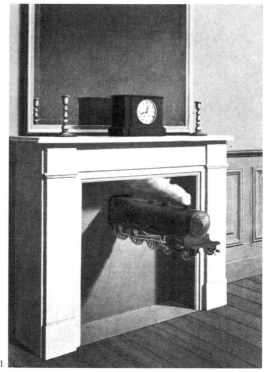

41

42

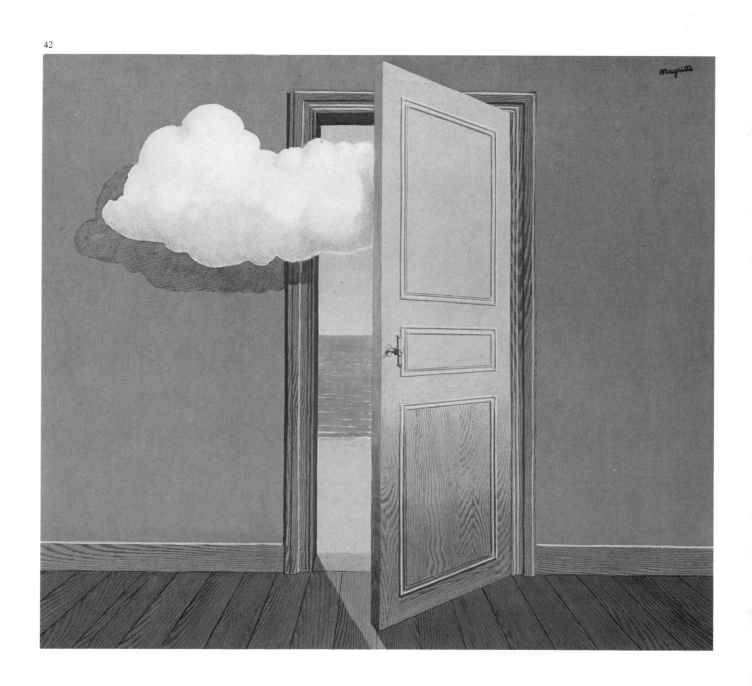

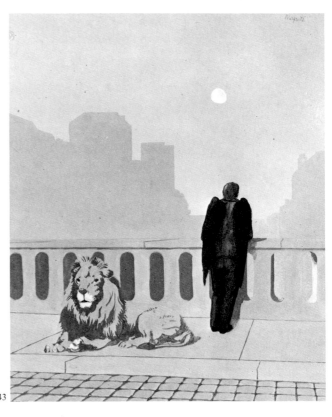

43

44

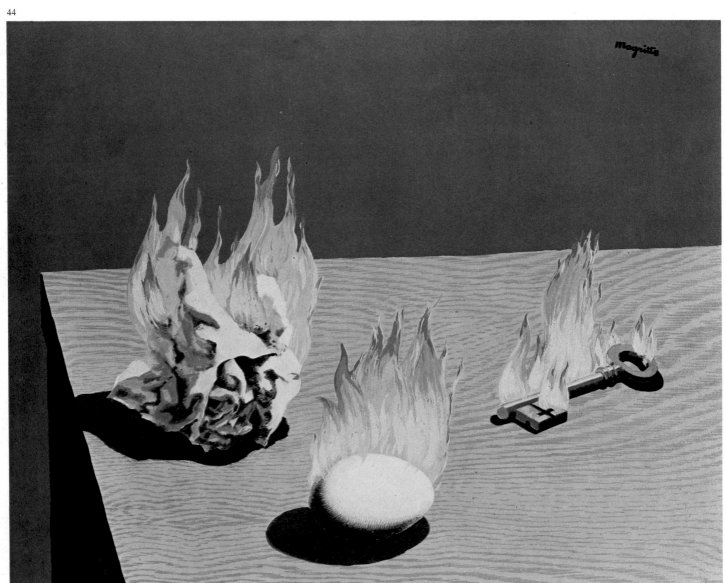

43. *Homesickness*. 1940.
 Gouache, 45 × 34 cm.
 The Art Institute of Chicago, Chicago.

44. *The Ladder of Fire*. 1939.
 Gouache, 27 × 34 cm.
 Collection of the Edward James Foundation, Chichester, Sussex.

45. *Treasure Island*. 1942.
 Oil on canvas, 70 × 93 cm.
 Mme. René Magritte Collection, Brussels.

45

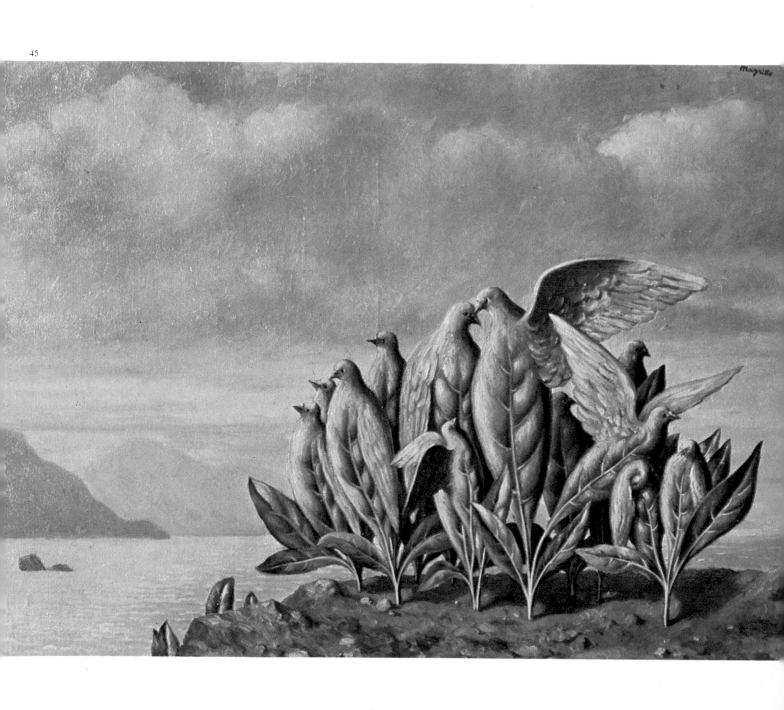

46. *The Present*. 1939.
Gouache.
Private collection, Belgium.

47. *The Natural Graces*. 1942.
Gouache, 41.5 × 59.5 cm.
Private collection, Brussels.

48. *The Inward Gaze*. 1942.
Oil on canvas, 60 × 74 cm.
Private collection, Brussels.

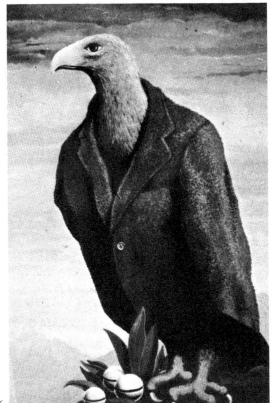

46

47

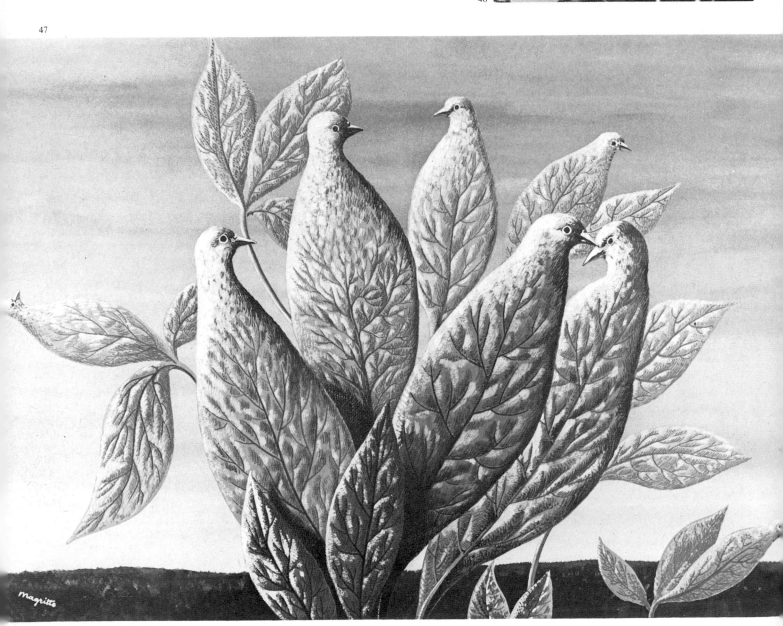

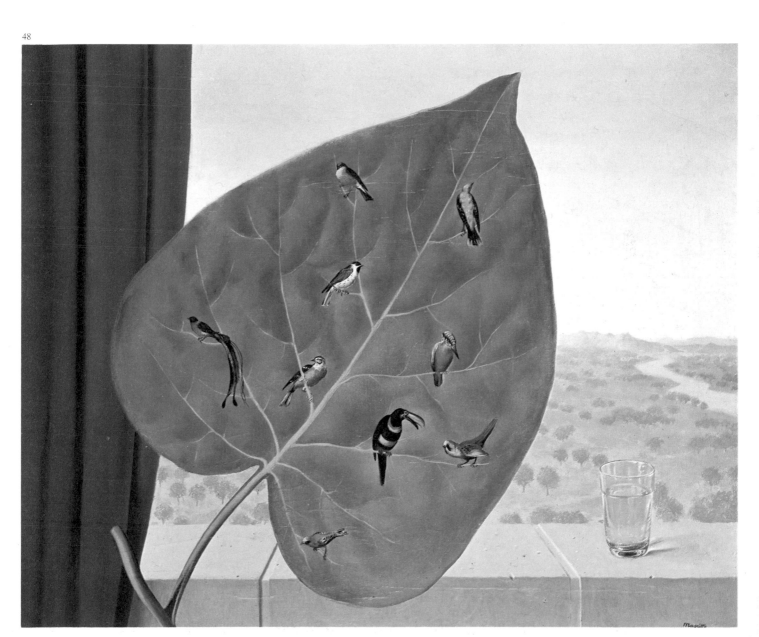

48

49

49. *The First Day*. 1943.
 Oil on canvas, 60×55 cm.
 Dr. Jean Robert Collection, Brussels.

50. *The Principle of Uncertainty*. 1944.
 Oil on canvas, 65×51 cm.
 Private collection, Brussels.

51. *The Harvest*. 1944.
 Oil on canvas, 60×80 cm.
 M. and Mme. Louis Scutenaire Collection, Brussels.

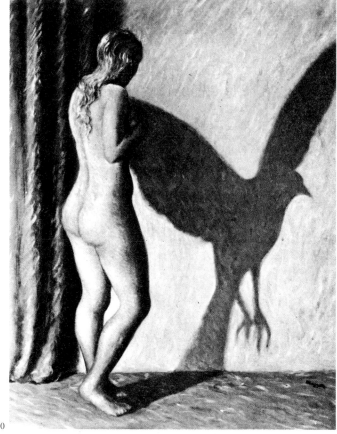

50

51

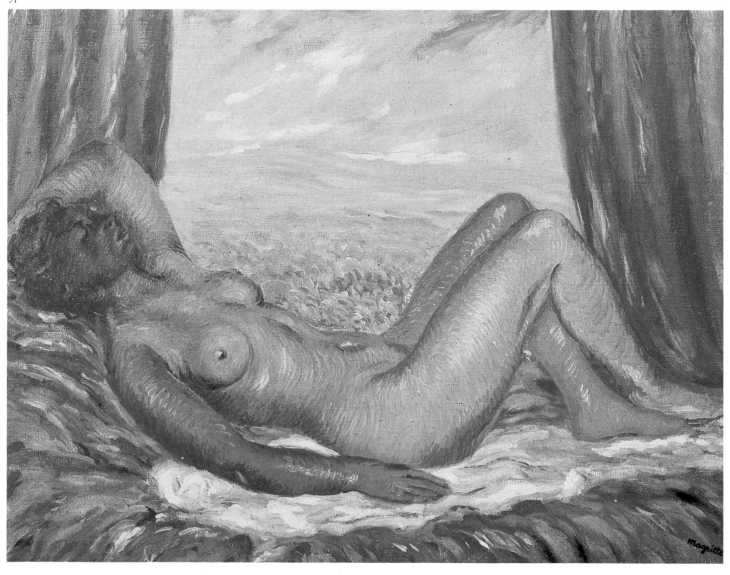

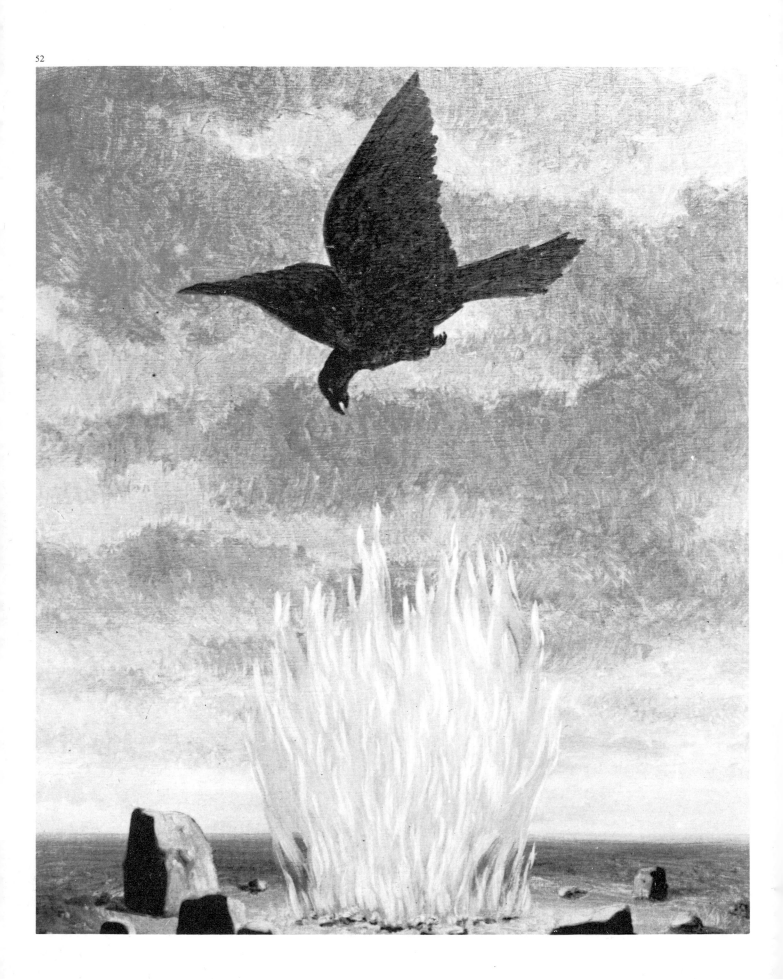

52. *The Fanatics*. 1945.
 Oil on canvas, 60 × 50 cm.
 Nellens Collection, Knokke-le-Zoute,
 Belgium.

53. *The Good Omens*. 1944.
 Oil on canvas, 40 × 60 cm.
 M. and Mme. Berger-Hoyez Collection,
 Brussels.

54. *The Smile*. 1944.
 Oil on canvas, 55 × 65 cm.
 M. and Mme. Louis Scutenaire Collection,
 Brussels.

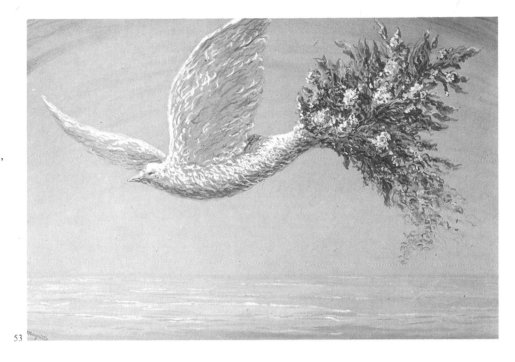

53

54

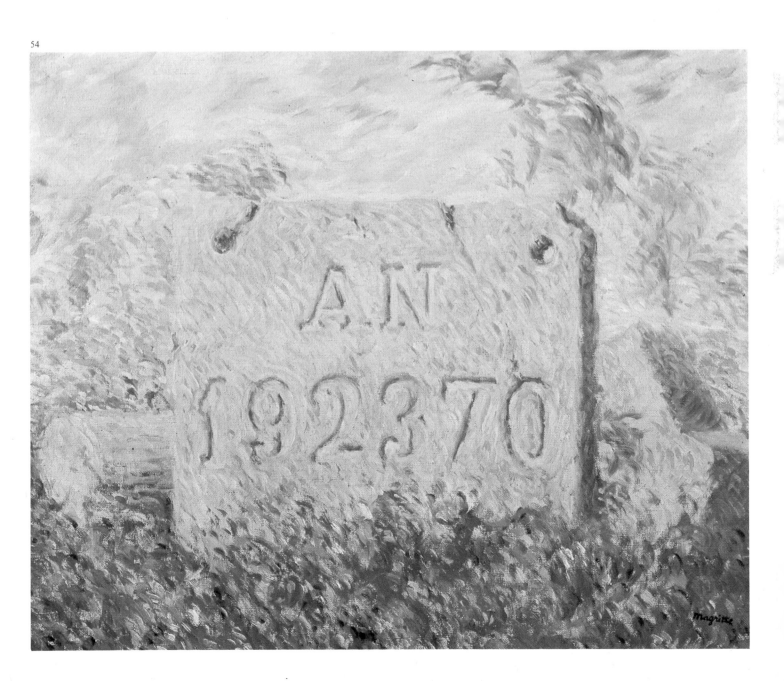

55. *Natural Encounters*. 1945.
 Oil on canvas, 80×65 cm.
 M. and Mme. Louis Scutenaire Collection, Brussels.

56. *Philosophy in the Boudoir*. 1947.
 Oil on canvas, 81×61 cm.
 Private collection, Washington, D.C.

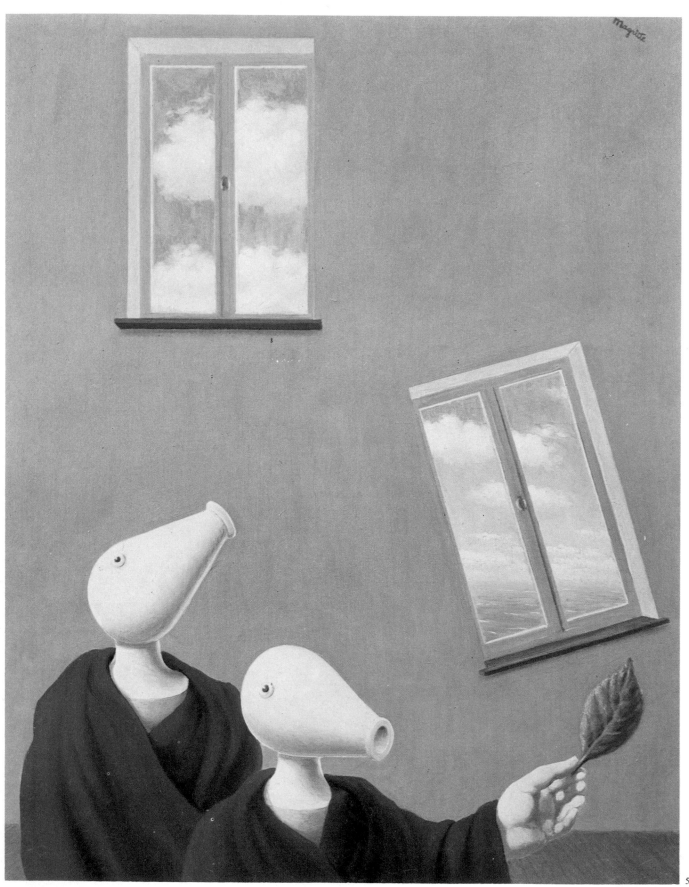

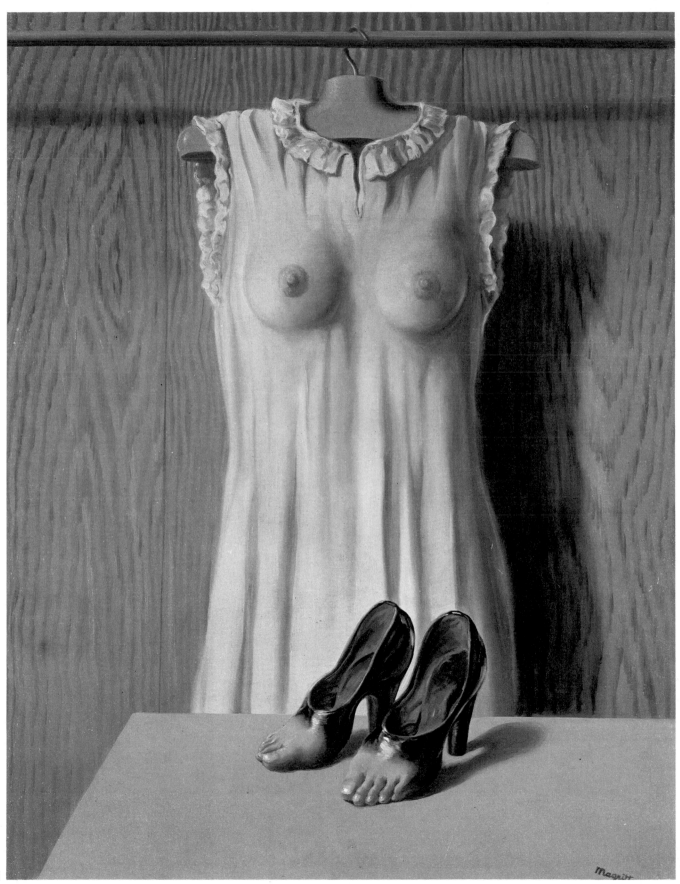

57. *The Rights of Man*. 1947.
 Oil on canvas, 146×114 cm.
 Galleria d'Arte del Naviglio, Milan.

58. *The Large Family*. 1947.
 Oil on canvas, 100×81 cm.
 Nellens Collection, Knokke-le-Zoute, Belgium.

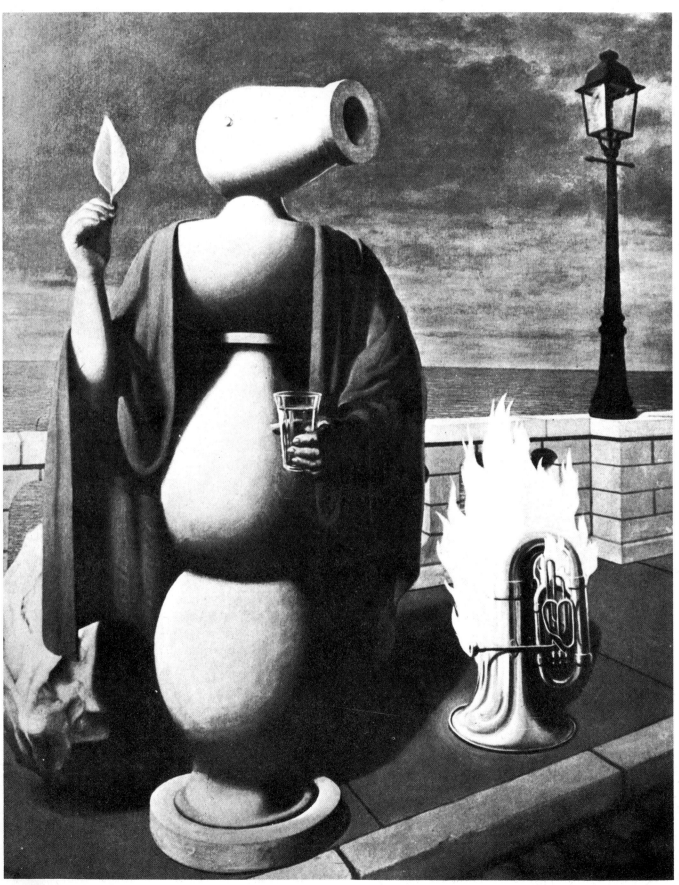

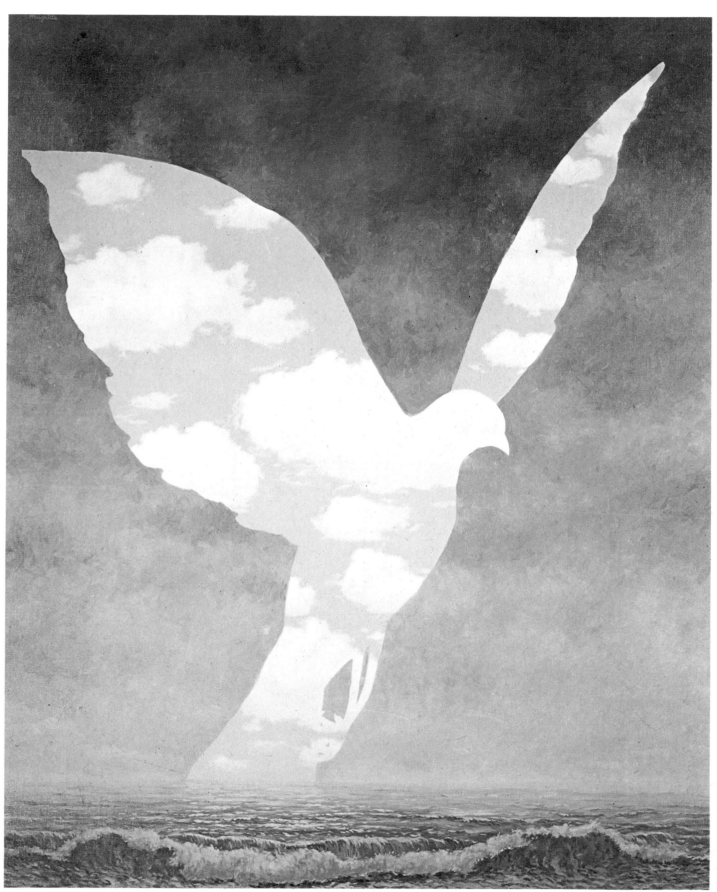

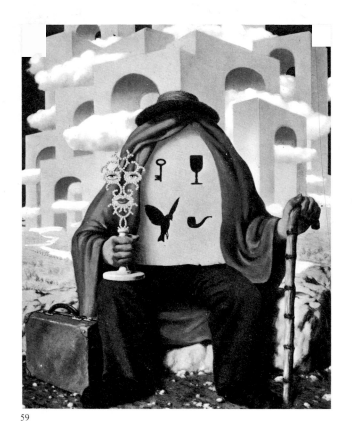

59

60

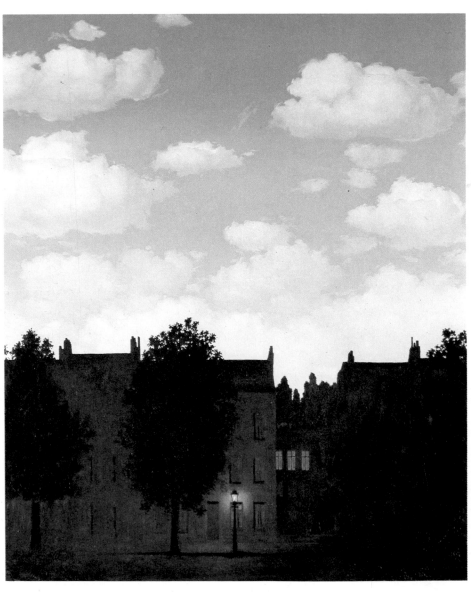

61

59. *The Liberator*. 1947.
 Oil on canvas, 99 × 79 cm.
 Los Angeles County Museum of Art, Los Angeles.

60. *The Flavor of Tears*. 1948.
 Oil on canvas, 58 × 48 cm.
 Richard S. Zeisler Collection, New York.

61. *The Empire of Lights*. 1948.
 Oil on canvas, 100 × 80 cm.
 Private collection, Brussels.

62. *The Empire of Lights II*. 1950.
 Oil on canvas, 79 × 99 cm.
 The Museum of Modern Art, New York.

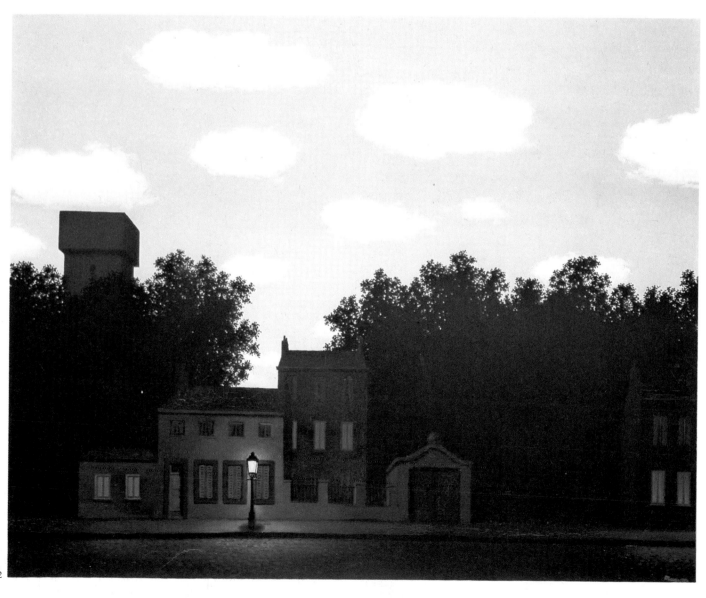

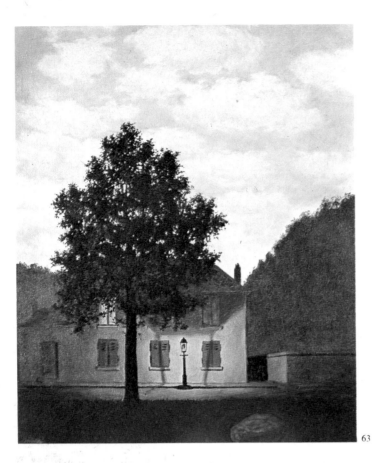

63. *The Empire of Lights*. 1958.
Oil on canvas, 49.5 × 39.5 cm.
Private collection, New York.

64. *The Empire of Lights*. 1953.
Oil on canvas, 37 × 45 cm.
Arnold Wessberger Collection, New York.

65. *The Empire of Lights*. 1954.
Oil on canvas, 146 × 114 cm.
Musées Royaux des Beaux-Arts, Brussels.

64

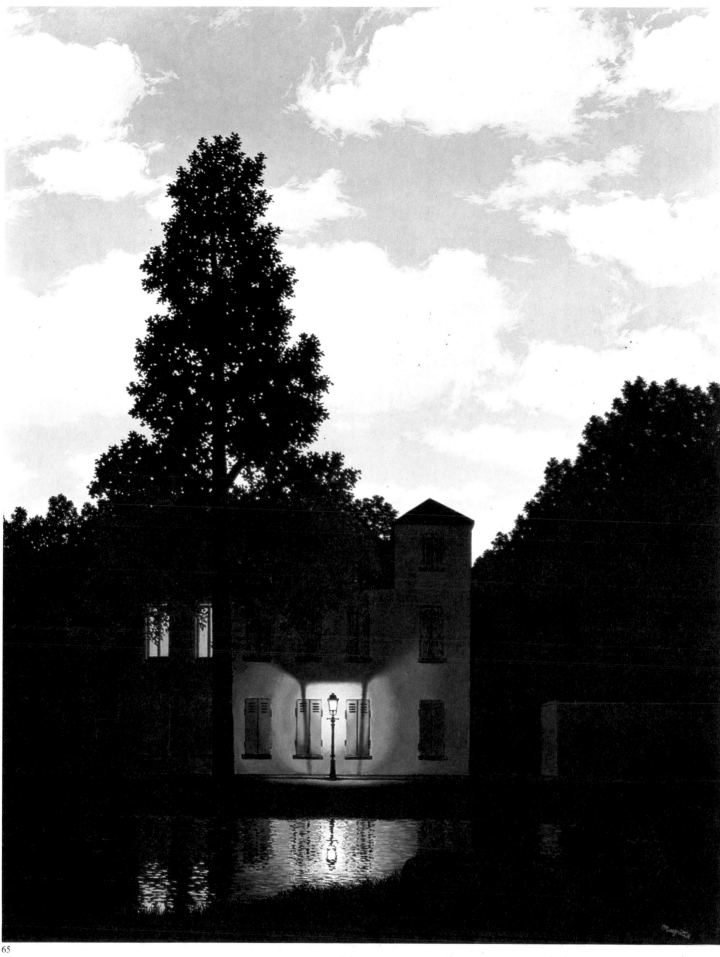

65

66

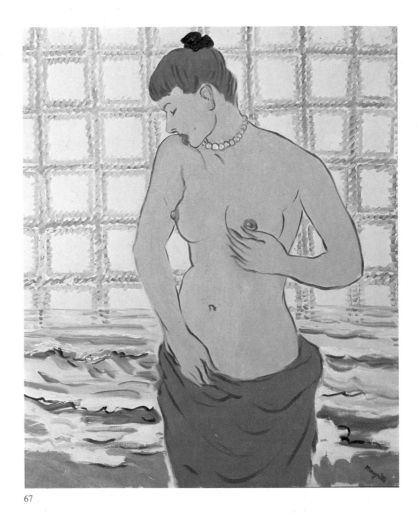

67

66. *Prince Charming*. 1948.
 Gouache, 45×32 cm.
 M. and Mme. Louis Scutenaire Collection, Brussels.

67. *The Pebble*. 1948.
 Oil on canvas, 110×80 cm.
 Mme. René Magritte Collection, Brussels.

68. *Lola de Valence*. 1948.
 Oil on canvas, 100×60 cm.
 M. and Mme. Louis Scutenaire Collection, Brussels.

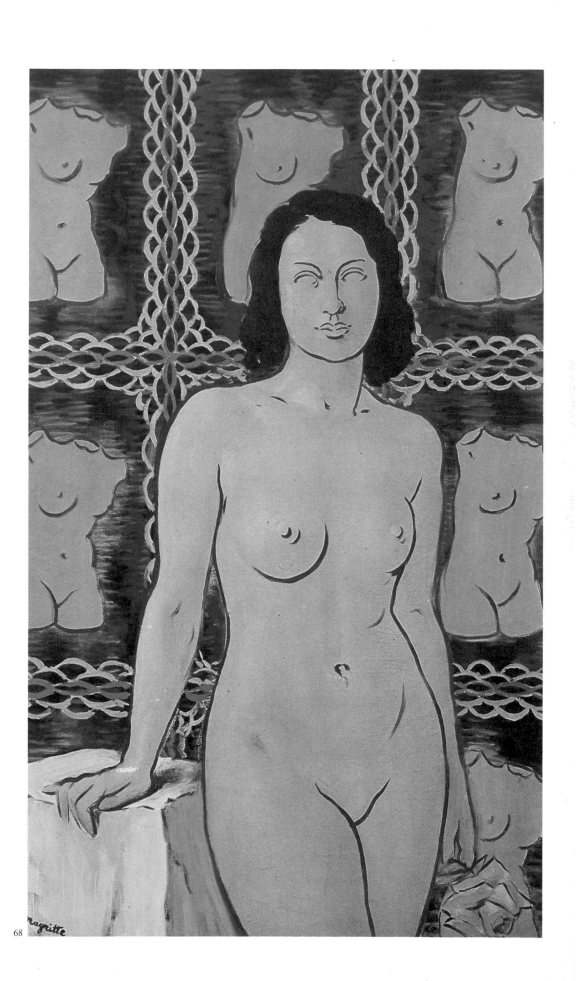

69. *Dark and Handsome*. 1950.
Oil on canvas, 58×48 cm.
The Israel Museum, Jerusalem.

70. *The Dark Glasses*. 1951.
Oil on canvas, 57.7×48.5 cm.
Private collection, New York.

71. *Siren Song*. 1952.
Oil on canvas, 100×81 cm.
Private collection, United States.

72. *The Song of the Violet*. 1951.
Oil on canvas, 100×81 cm.
Private collection, Brussels.

70

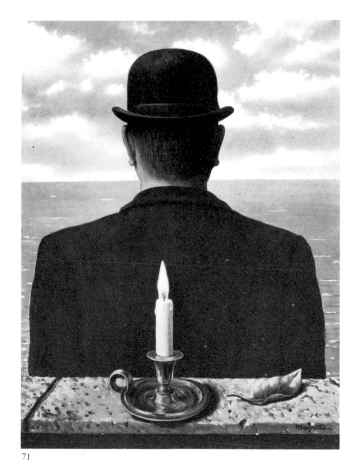

71

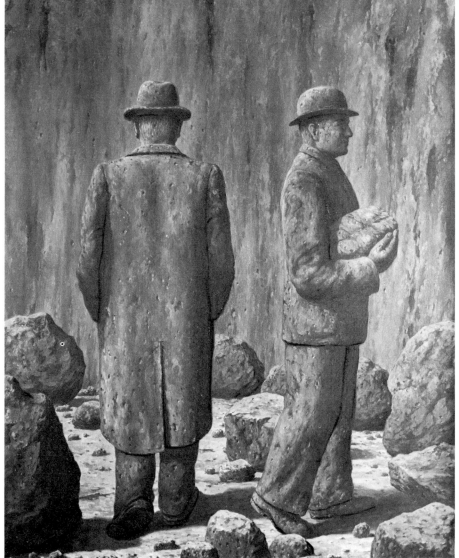

72

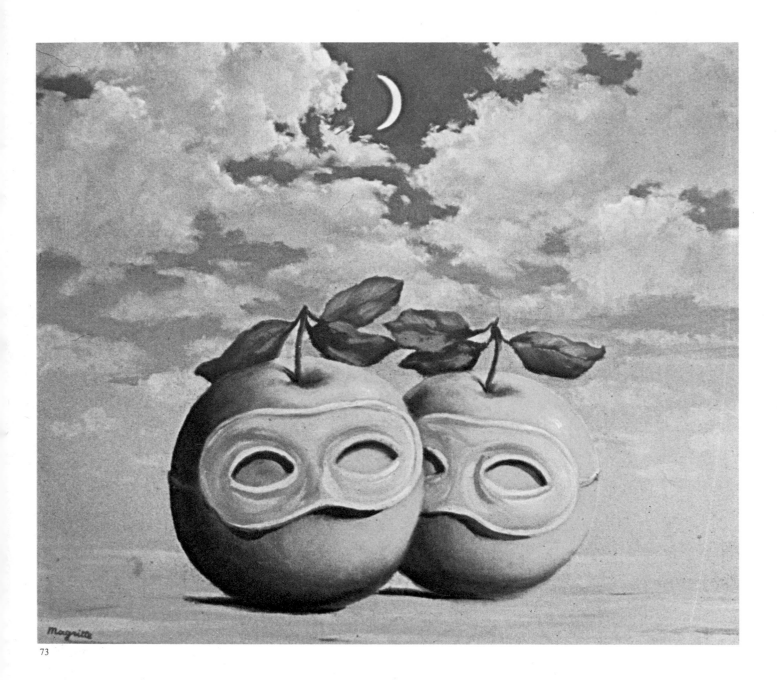

73

73. *The Married Priest*. 1950.
 Oil on canvas, 46 × 58 cm.
 Mme. René Magritte Collection, Brussels.

74. *Pandora's Box*. 1951.
 Oil on canvas, 46.5 × 55 cm.
 Yale University Art Gallery, New Haven, Connecticut.

75. *The Magician* (self-portrait with four arms). 1952.
 Oil on canvas, 35 × 46 cm.
 Mme. J. Van Parys Collection, Brussels.

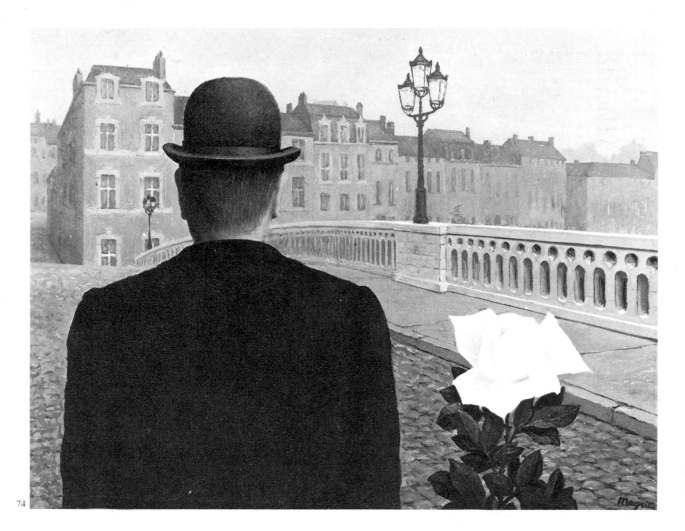

74

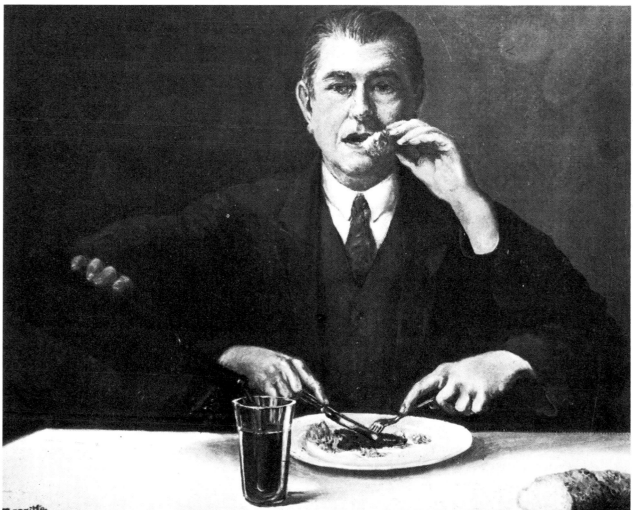

75 Magritte

76. *The Blow to the Heart.* 1952.
 Oil on canvas, 45×37 cm.
 Richard S. Zeisler Collection, New York.

77. *Personal Values.* 1952.
 Oil on canvas, 81×100 cm.
 Private collection, New York.

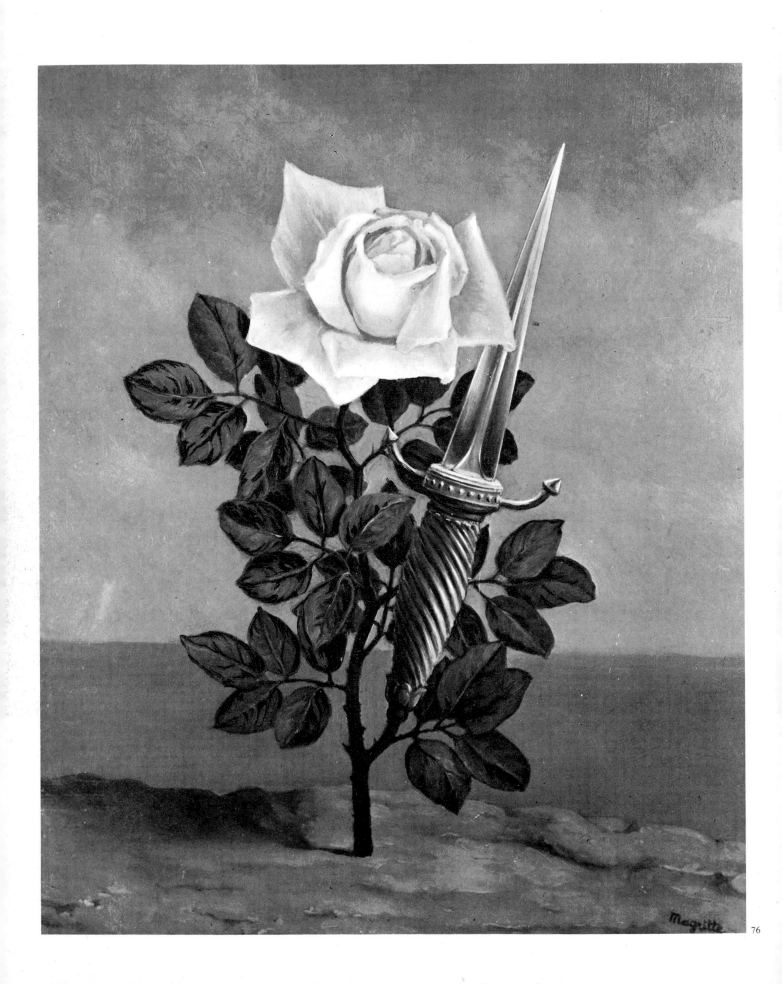

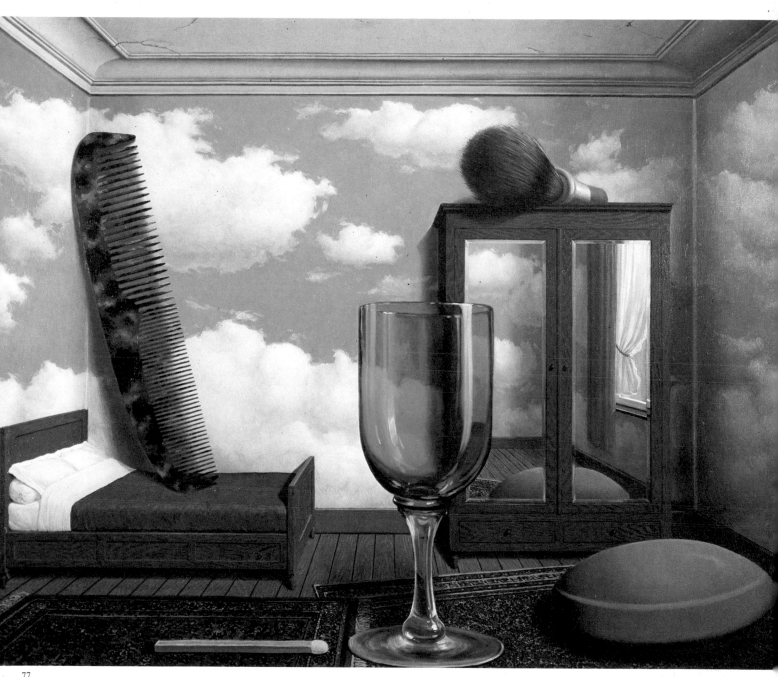

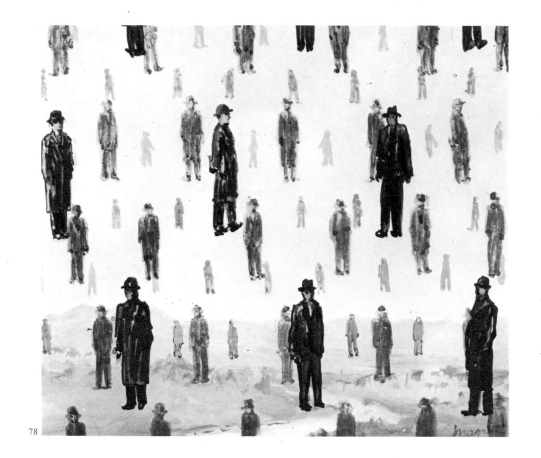

78

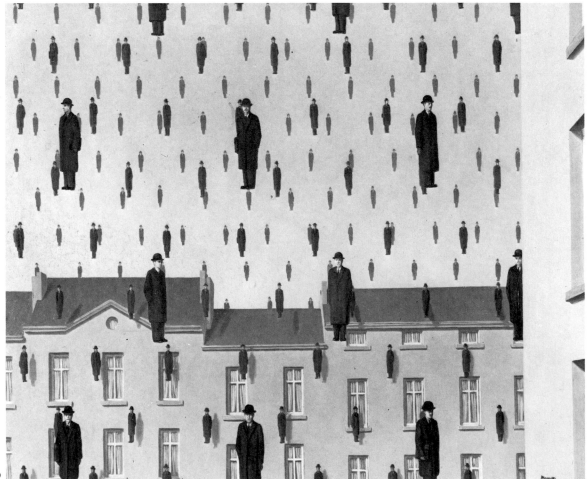

79

78. *Golconde*. 1953.
 Gouache, 15×17 cm.
 M. and Mme. Louis Scutenaire Collection, Brussels.

79. *Golconde*. 1953.
 Oil on canvas, 81×100 cm.
 Private collection, United States.

80. *The Good Example*. 1953.
 (Portrait of Alexandre Iolas).
 Oil on canvas, 46×33 cm.
 André Mourgues Collection, Paris.

81. Fragments of a letter from René Magritte to Marcel Mariën (1953) about the problem of the piano.

82. *The Happy Hand.* 1953.
Oil on canvas, 50×65 cm.
Private collection, United States.

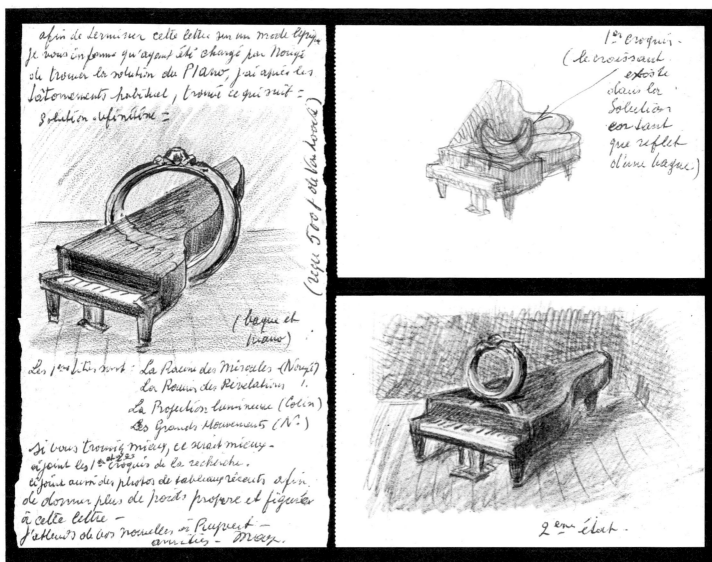

81

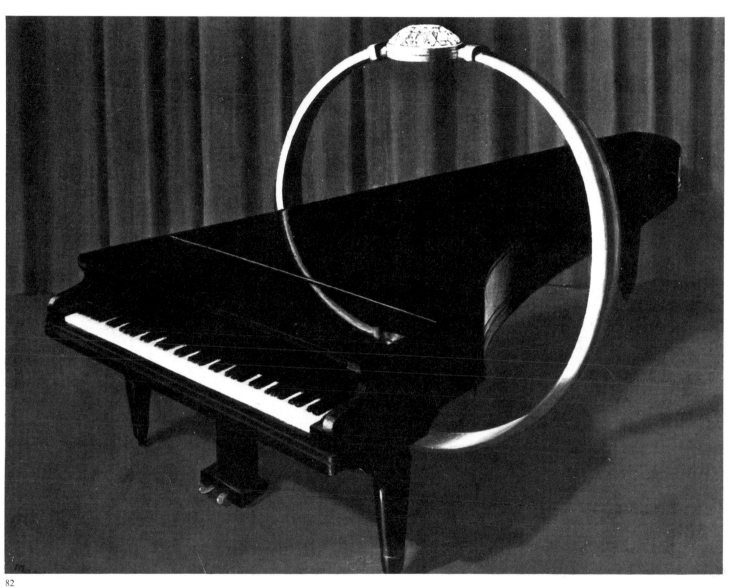

83. *Holiday*. 1954.
 Gouache, 33 × 28 cm.
 Mme. Denise Wiseman Collection, New York.

84. *The Listening Room I*. 1953.
 Oil on canvas, 80 × 100 cm.
 William N. Copley Collection, New York.

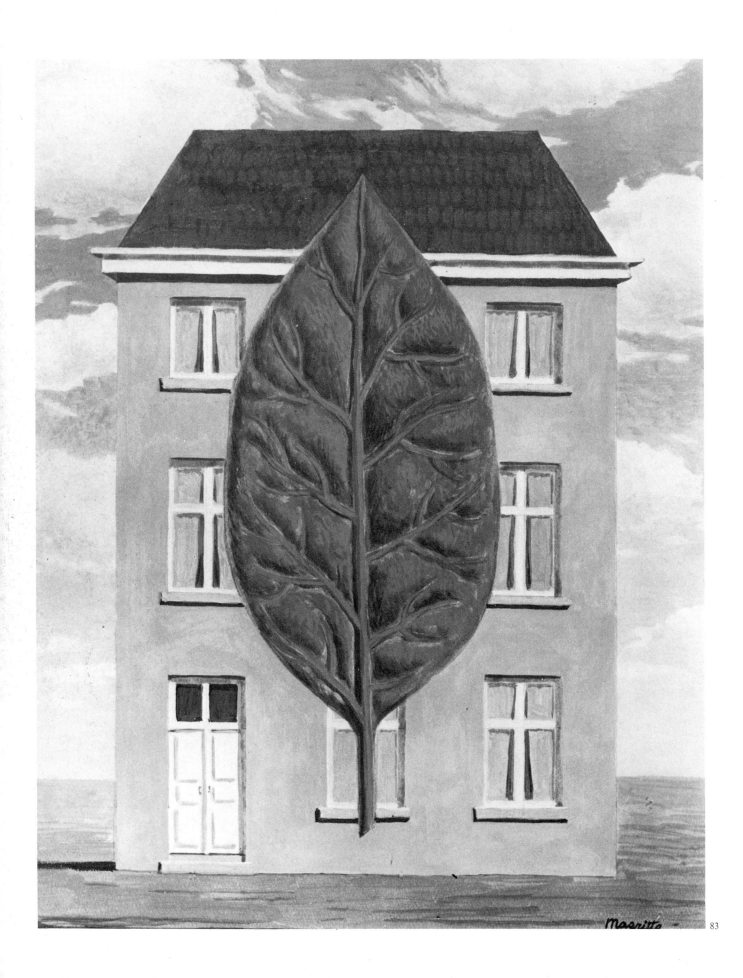

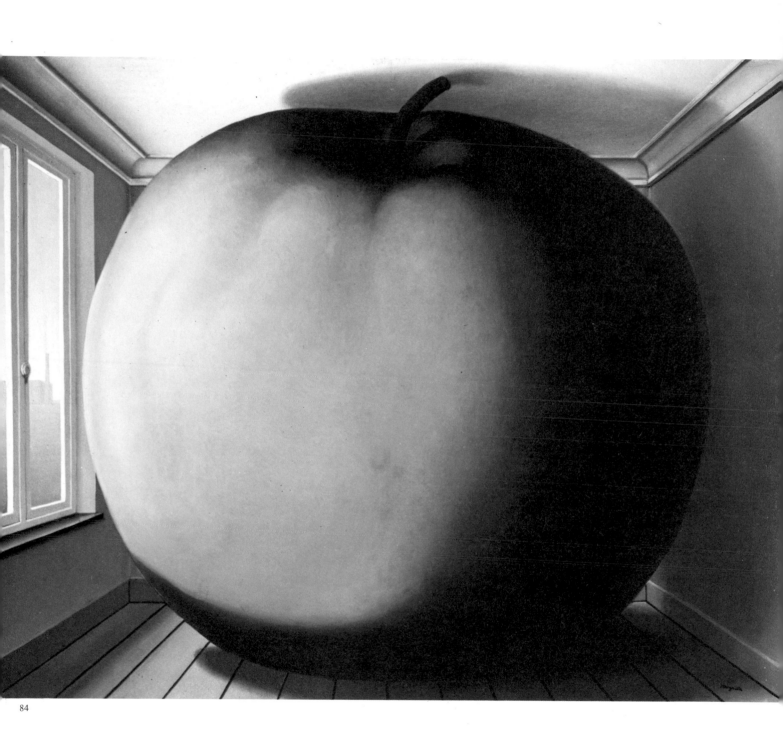

85. *The Evening Dress*. 1955.
 Oil on canvas, 80×60 cm.
 Private collection, Brussels.

86. *Memory of a Voyage*. 1955.
 Oil on canvas, 163×130 cm.
 The Museum of Modern Art, New York.

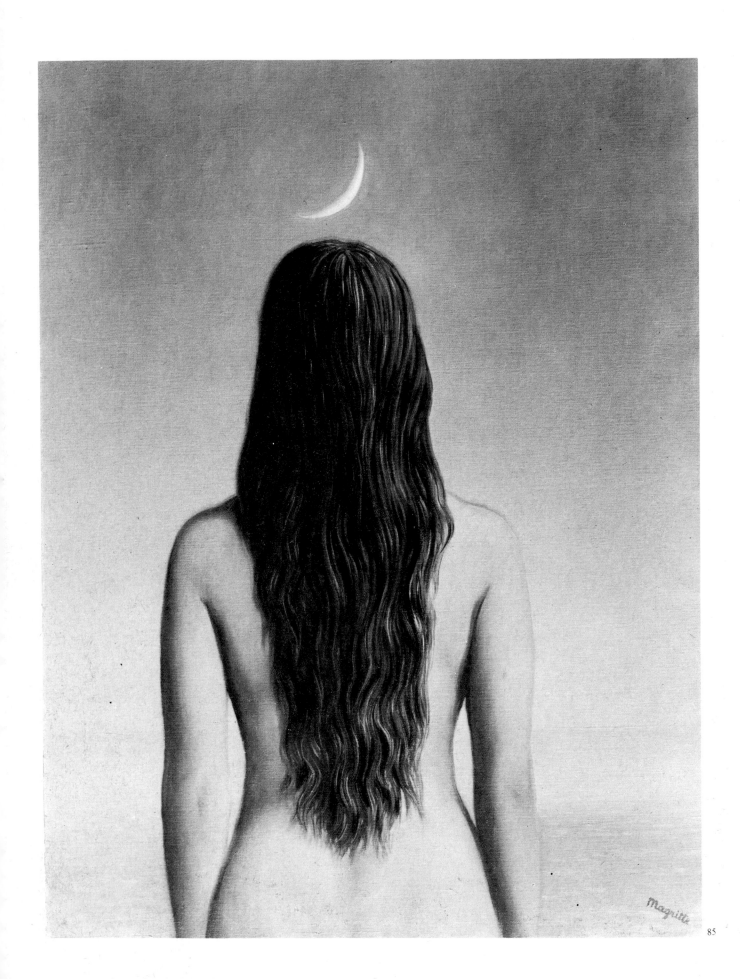

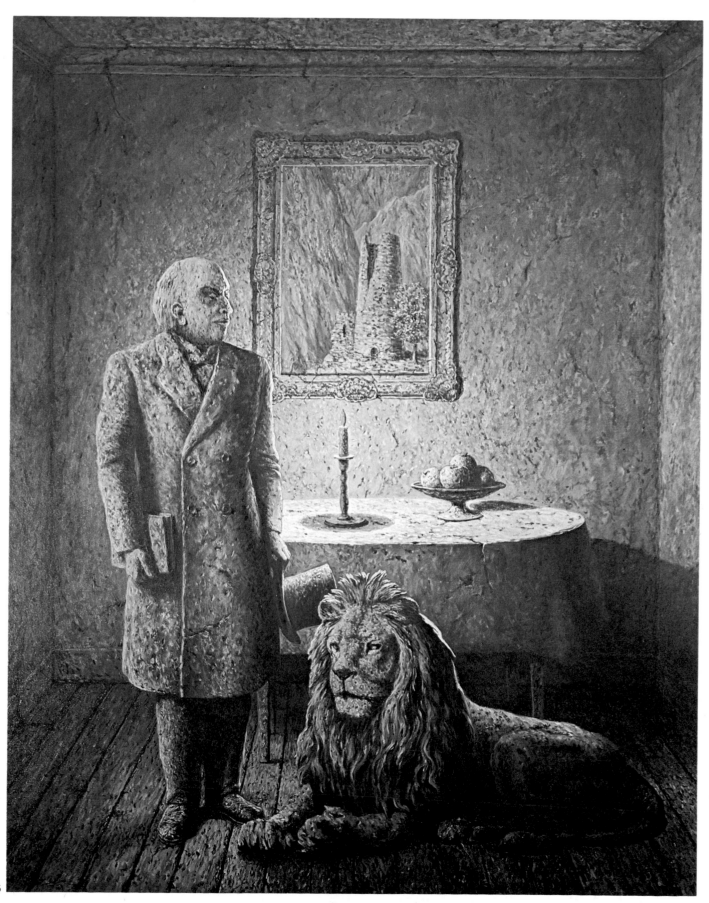

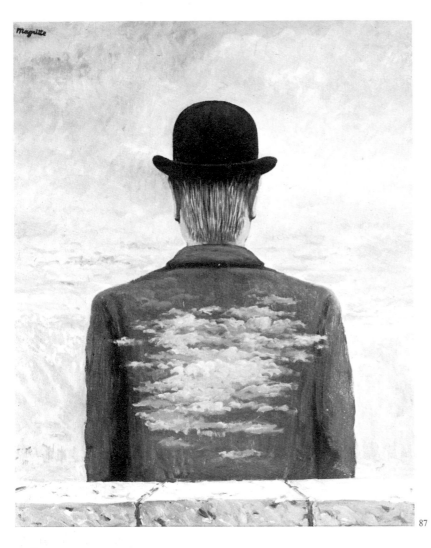

87

87. *The Poet Rewarded*. 1956.
Oil on canvas.
Private collection, United States.

88. *The Masterpiece* or *The Mysteries of the Horizon*. 1955.
Oil on canvas, 49.5 × 65 cm.
Arnold L. Weissberger Collection, New York.

89. *Euclidean Walks*. 1955.
Oil on canvas, 163 × 130 cm.
The Minneapolis Institute of Arts, Minneapolis.

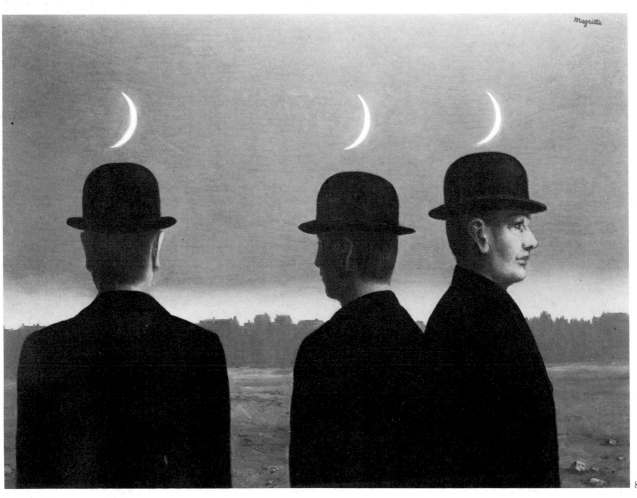

88

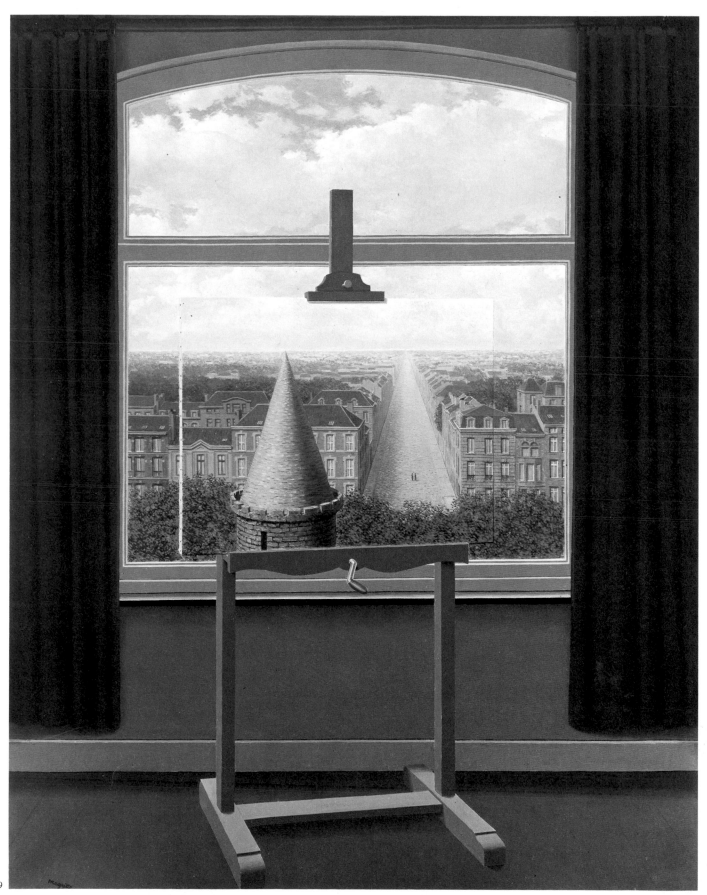

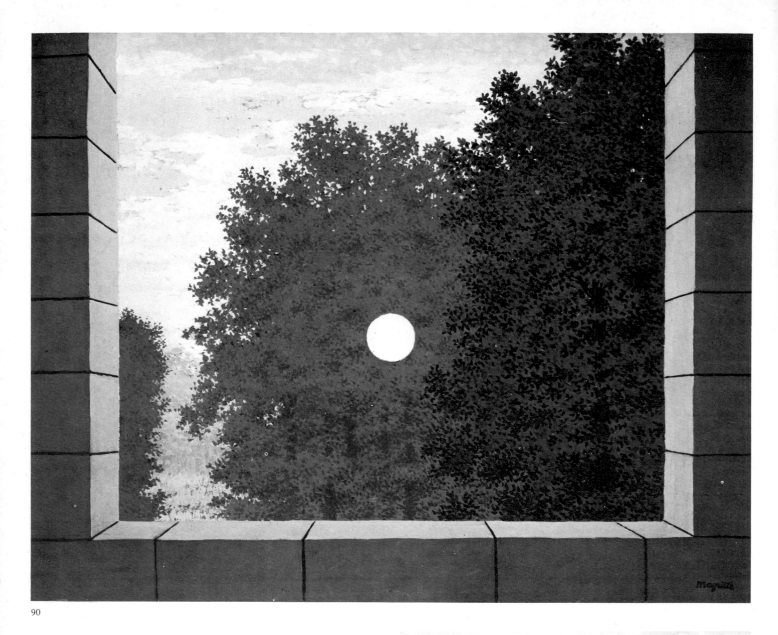

90

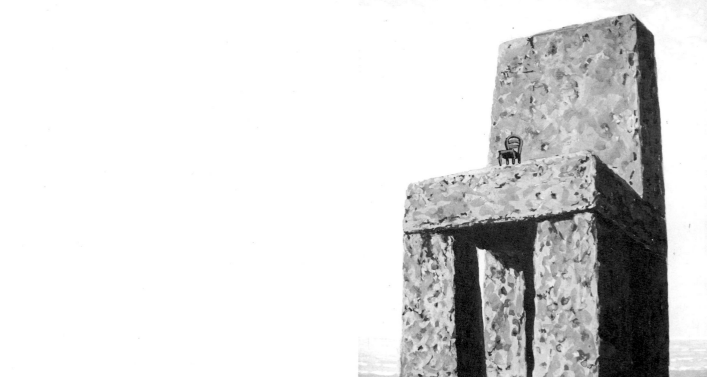

91

90. *The Banquet.* 1956.
 Gouache, 36 × 47 cm.
 Private collection, United States.

91. *The Legend of the Centuries.* 1950.
 Gouache, 25 × 20 cm.
 Private collection, United States.

92. *The Legend of the Centuries.* 1958.
 Pen-and-ink and pencil, 18 × 10 cm.
 Harry Torczyner Collection, New York.

Chaise rouge sur une chaise
de pierre rongée par le temps.
ciel clair — (peut être vue au moment où le ciel
nocturne

93. *The Hole in the Wall*. 1956.
 Oil on canvas, 100×80 cm.
 Hans Neumann Collection, Caracas.

94. *Justice Has Been Done*. 1958.
 Oil on canvas, 39.5×29.2 cm.
 Private collection, New York.

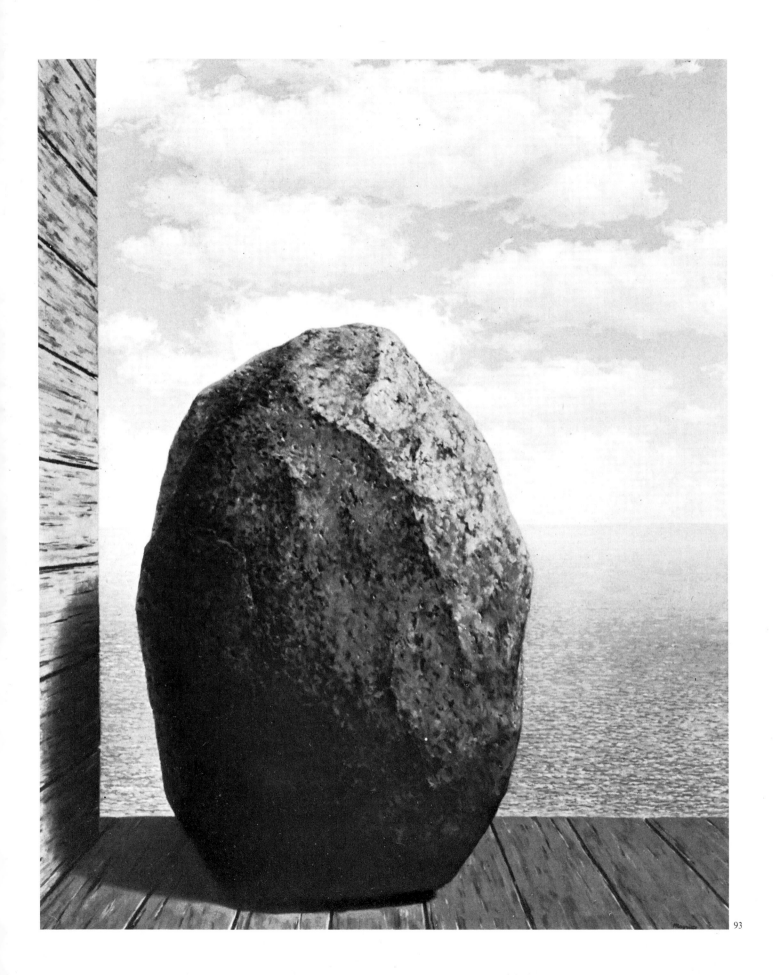

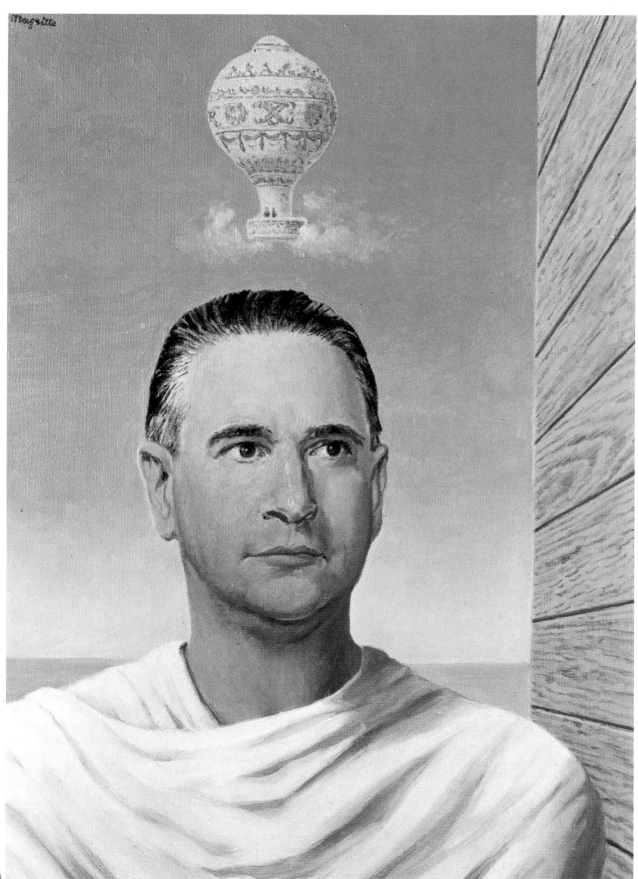

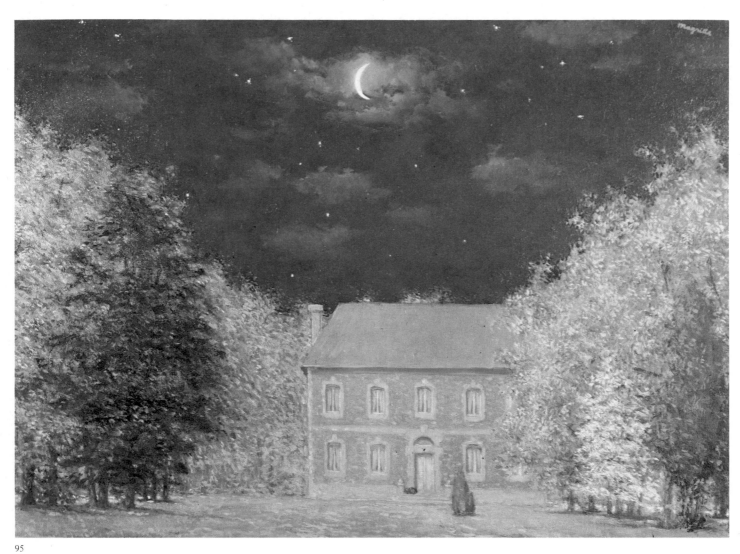

95

95. *God's Drawing Room*. 1958.
 Oil on canvas, 43 × 59 cm.
 Arnold Weissberger Collection, New York.

96. *The Golden Legend*. 1958.
 Oil on canvas, 95 × 129 cm.
 Private collection, New York.

97. *The Power of Things*. 1958.
 Oil on canvas, 50.5 × 57 cm.
 University of St. Thomas Collection, Houston.

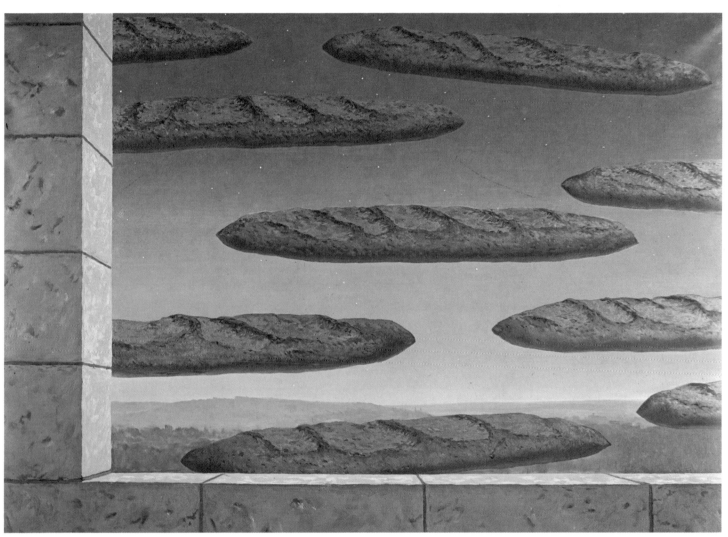

96

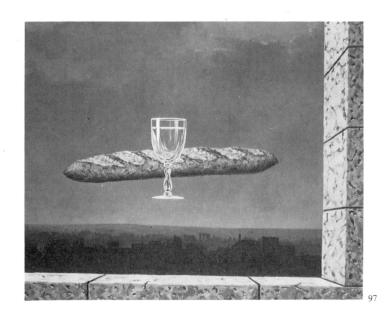

97

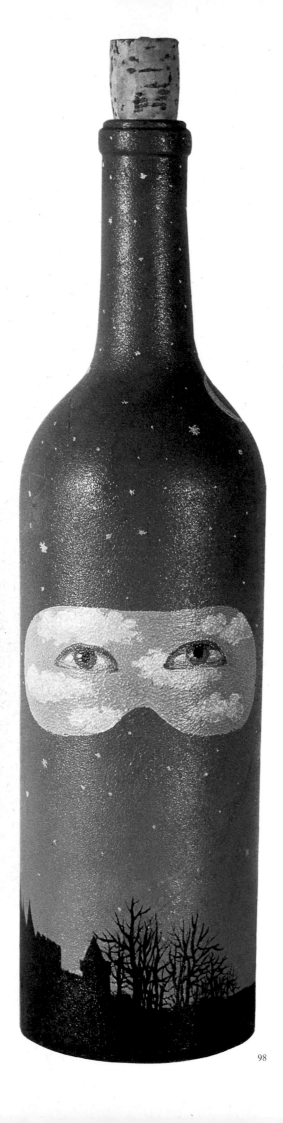

98

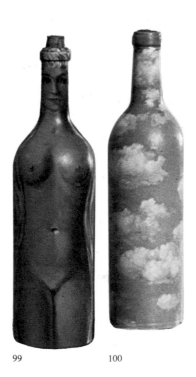

99 100

101

98. *Painted Bottle*. Undated.
 Height: 29 cm.
 M. and Mme. Marcel Mabille Collection, Rhode-St-Genèse, Belgium.

99. *The Lady*. Undated.
 Painted bottle; height: 32 cm.
 Mme. René Magritte Collection, Brussels.

100. *Sky*. Undated.
 Painted bottle; height: 30 cm.
 Mme. René Magritte Collection, Brussels.

101. *The Time of the Wine Harvest*. 1959.
 Oil on canvas, 130×160 cm.
 Private collection, Paris.

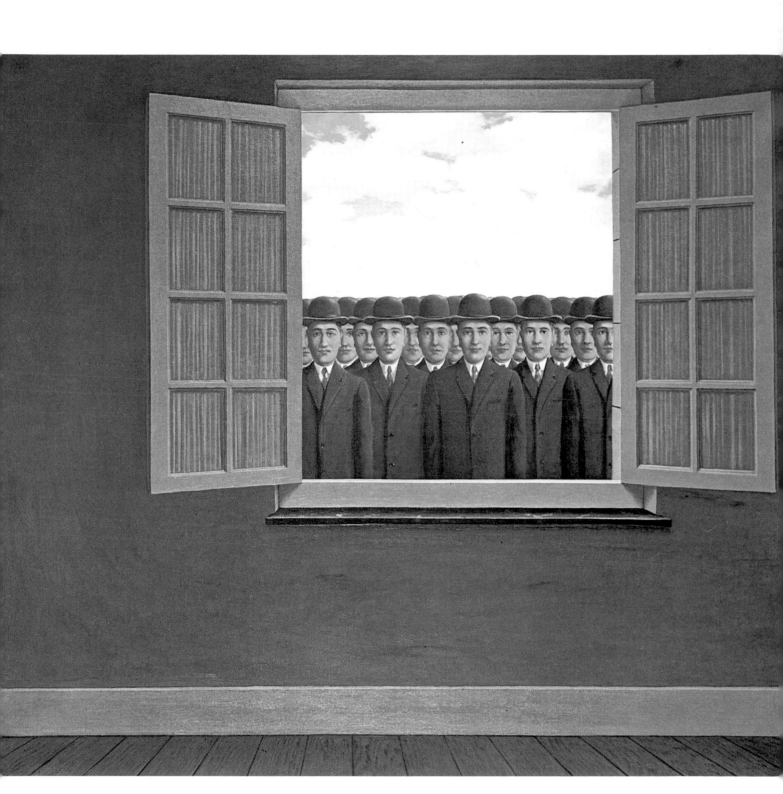

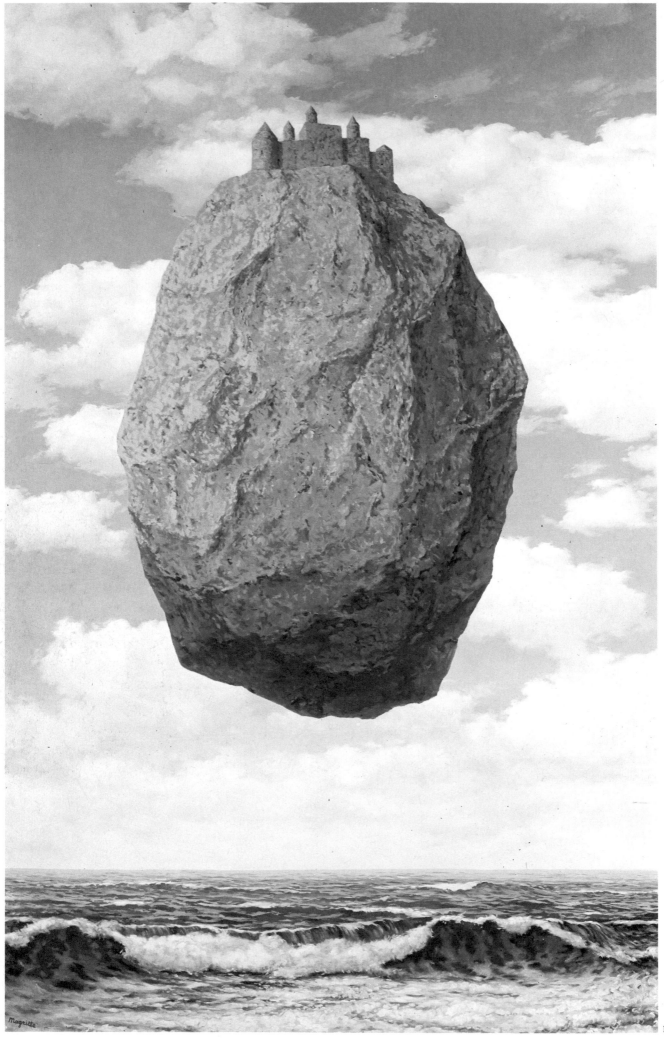

102. *The Castle of the Pyrenees*. 1959.
 Oil on canvas, 200×140.5 cm.
 Harry Torczyner Collection, New York.

103. *The Anniversary*. 1959.
 Oil on canvas, 89.5×116.5 cm.
 Art Gallery of Ontario, Toronto.

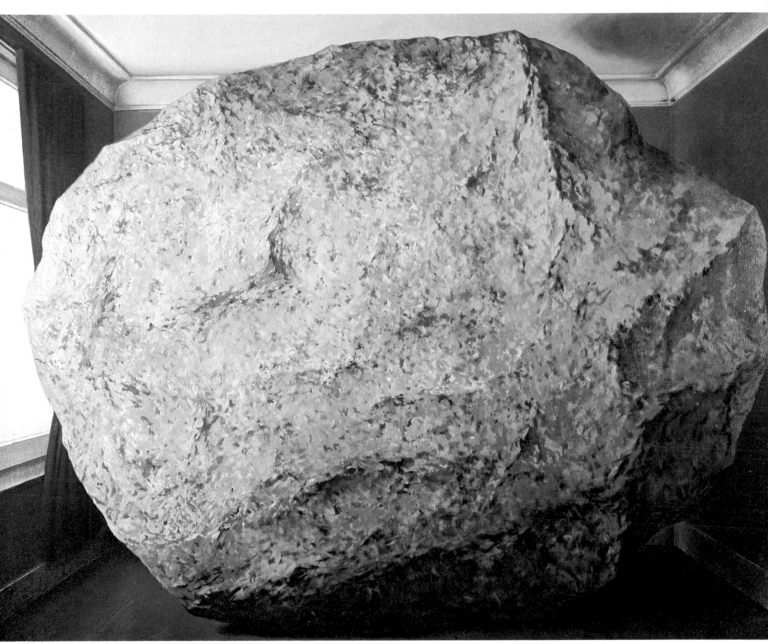

103

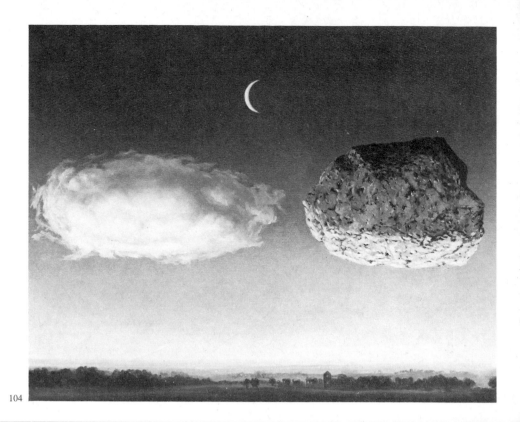

104

105

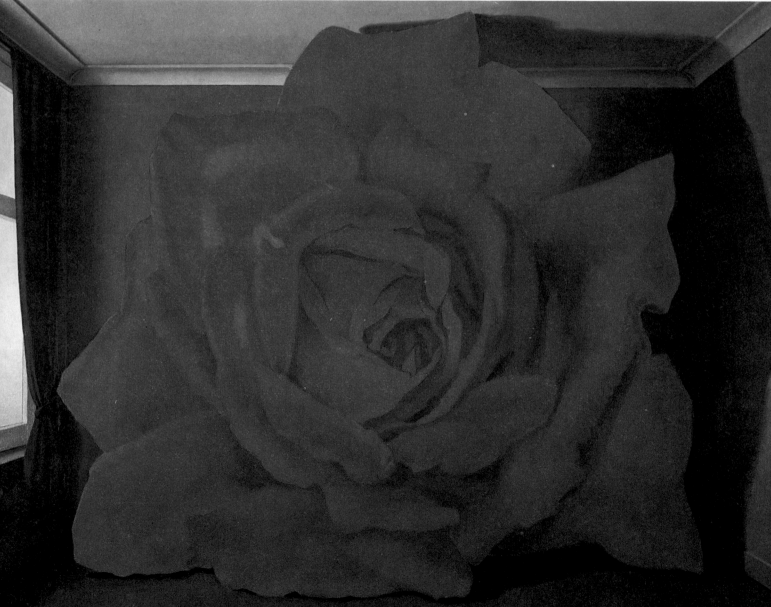

106

Trois objets près d'un rideau regardent
un bateau dans la tempête, d'un balcon
en pierre -

107

104. *The Battle of the Argonne*. 1959.
Oil on canvas, 49.5 × 61 cm.
Tazzoli Collection, Turin.

105. *The Tomb of the Wrestlers*. 1960.
Oil on canvas, 89 × 117 cm.
Harry Torczyner Collection, New York.

106. *A Simple Love Story*. 1958.
Oil on canvas, 40 × 30 cm.
Galleria La Medusa, Rome.

107. *Project for a Difficult Crossing*.
Pen-and-ink and pencil, 13 × 13 cm.
Harry Torczyner Collection, New York.

108. *The Postcard*. 1960.
Oil on canvas, 70 × 50.2 cm.
Private collection, United States.

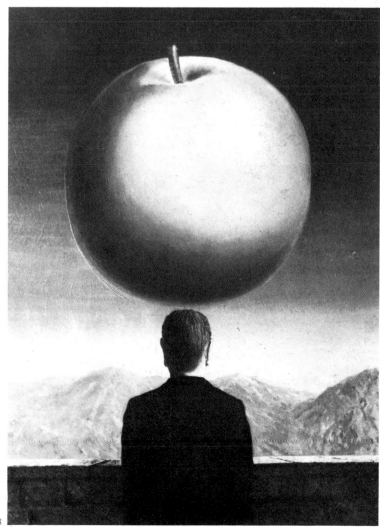

108

109

110

109. *Portrait* (M. Merlot). 1961.
Oil on canvas.
Merlot Collection, Brussels.

110. *Germaine Nellens*. 1962.
Gouache, 36 × 24 cm.
Nellens Collection, Knokke-le-Zoute, Belgium.

111. *The Beautiful World*. c. 1960.
Oil on canvas, 100 × 81 cm.
Private collection, Brussels.

112. *The Memoirs of a Saint*. 1960.
Oil on canvas, 80 × 100 cm.
Collection of the Menil Foundation, Houston.

113. *Plagiarism*. 1960.
Gouache, 30 × 25 cm.
Private collection, New York.

114. *The Country of Marvels*. c. 1960.
Oil on canvas, 55 × 46 cm.
Private collection, Brussels.

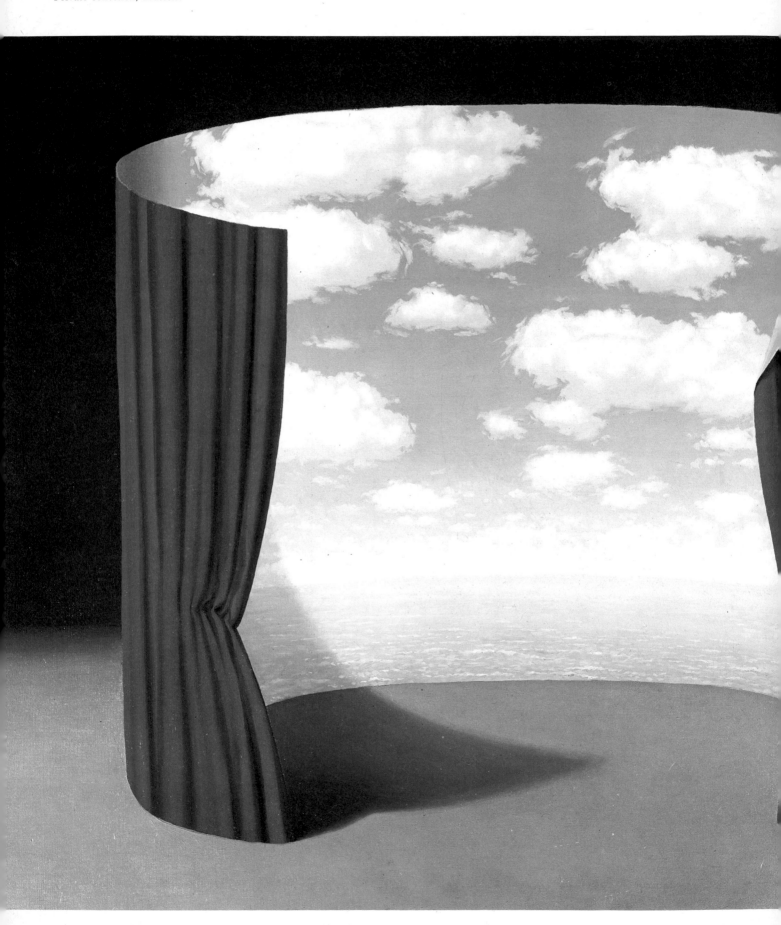

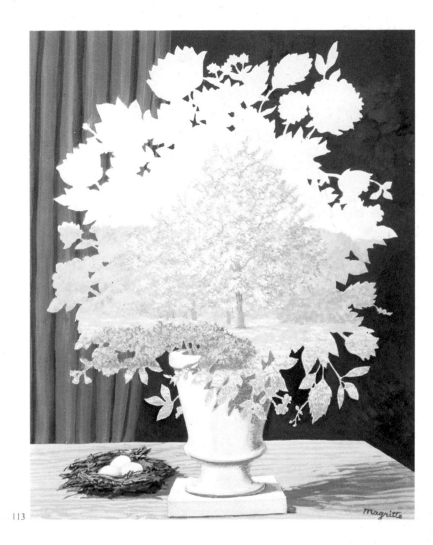

113

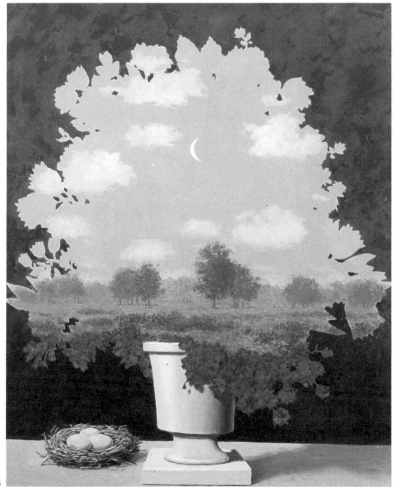

112 114

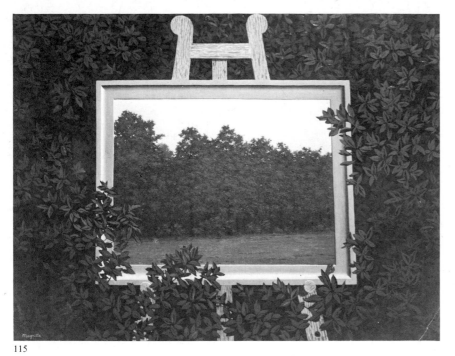

115

115. *The Waterfall*. 1961.
 Oil on canvas, 80 × 99 cm.
 Private collection.

116. *The Waterfall*. 1961.
 Gouache, 37 × 45 cm.
 Private collection, Gstaad.

117. *A Little of the Bandits' Soul*. 1960.
 Oil on canvas, 65 × 50 cm.
 Private collection.

116

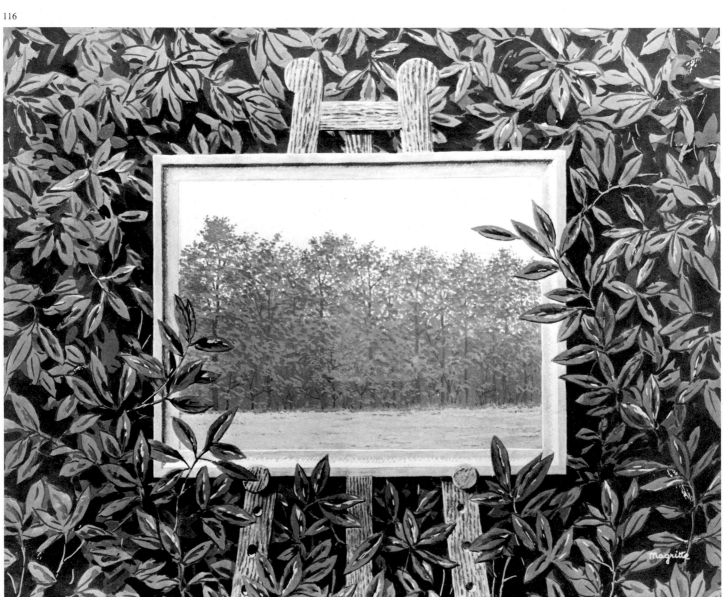

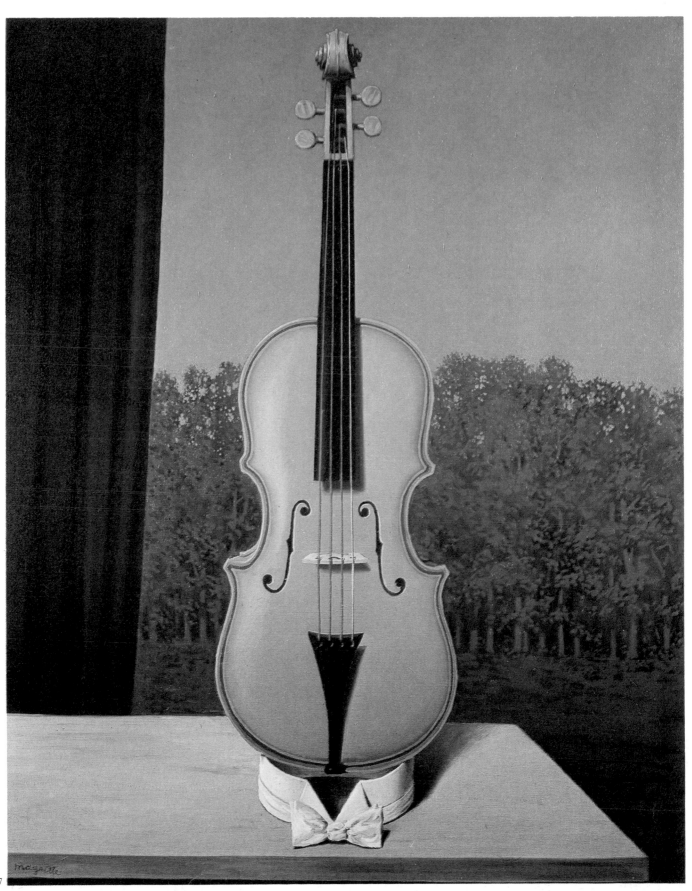

118. *The Call of Blood*. 1961.
Oil on canvas, 90×100 cm.
Private collection, Brussels.

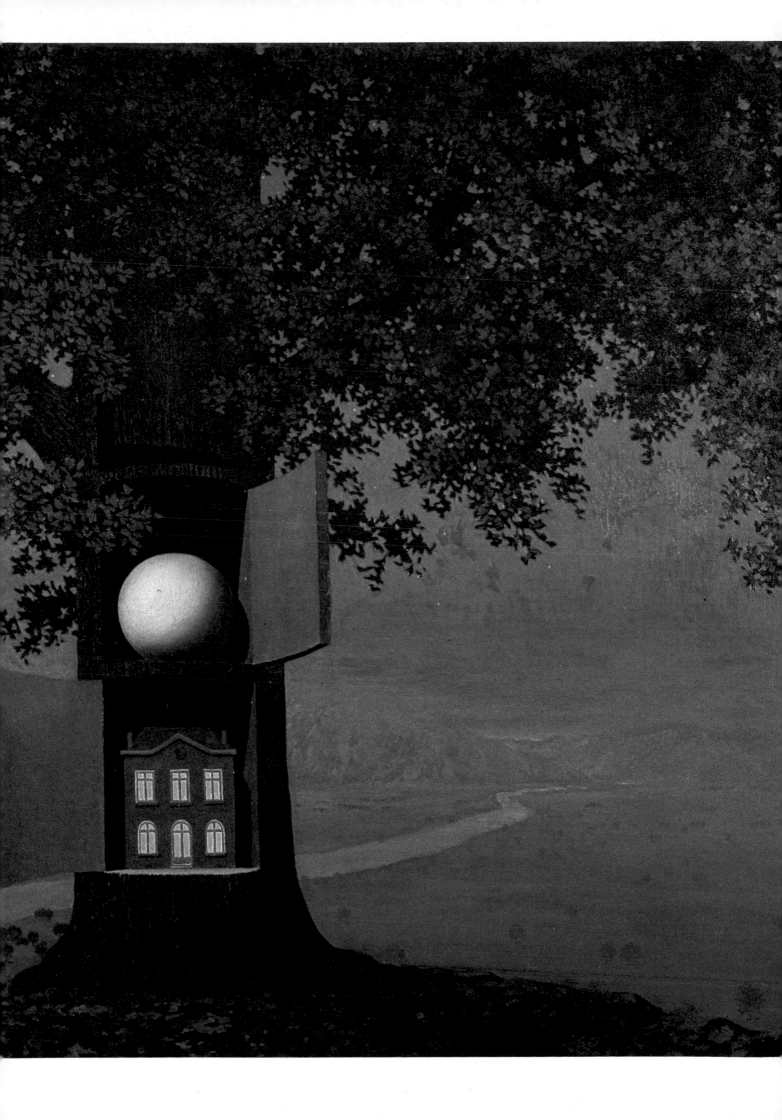

119. *The Bosom*. 1961.
 Oil on canvas, 90 × 110 cm.
 Private collection, Brussels.

120. *The Unmasked Universe*.
 Oil on canvas, 75 × 91 cm.
 Mme. Crik Collection, Brussels.

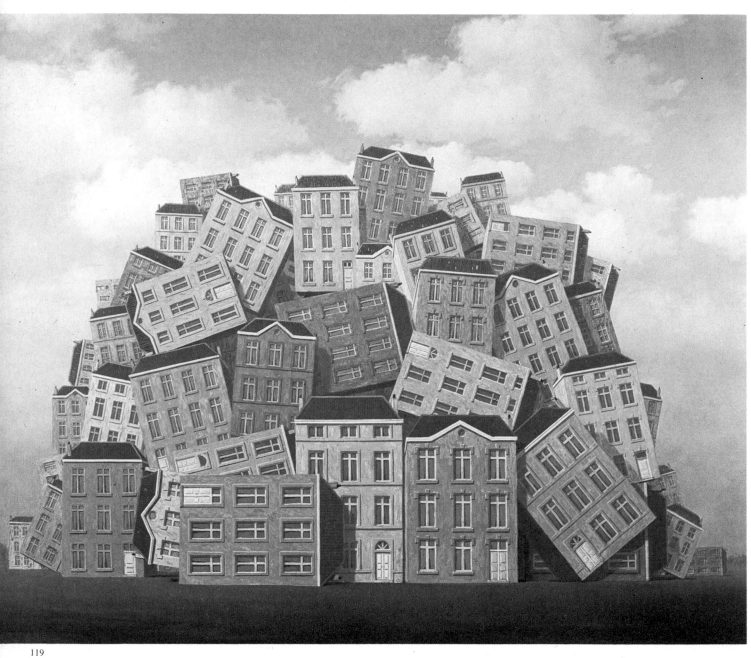

119

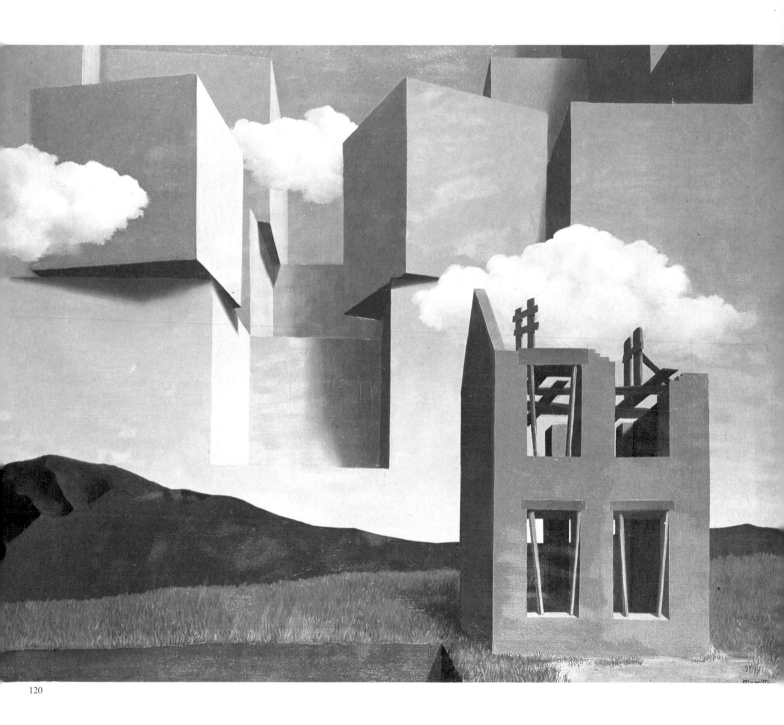

121. *The Natural Graces*. 1962.
Oil on canvas, 40 × 32 cm.
Mme. Suzanne Ochinsky Collection, Brussels.

122. *The Beautiful Realities*. 1963.
Pencil, 15 × 11 cm.
Harry Torczyner Collection, New York.

123. *The Exception*. 1963.
Oil on canvas, 33 × 41 cm.
Galerie Isy Brachot, Brussels.

124. *The Beautiful Realities*. 1964.
Oil on canvas, 50 × 40 cm.
Galerie Isy Brachot, Brussels.

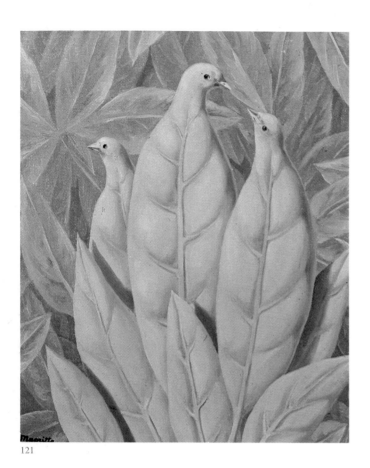

121

122

123

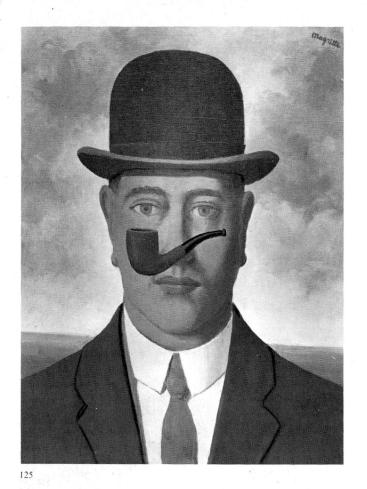

125

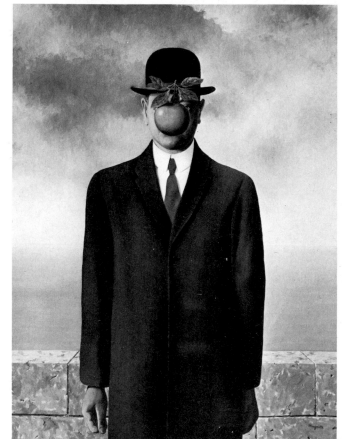

126

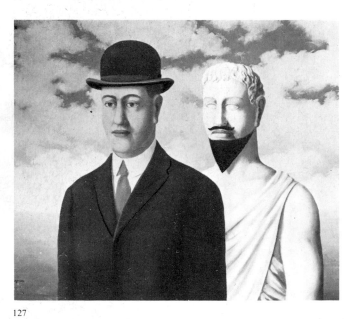

127

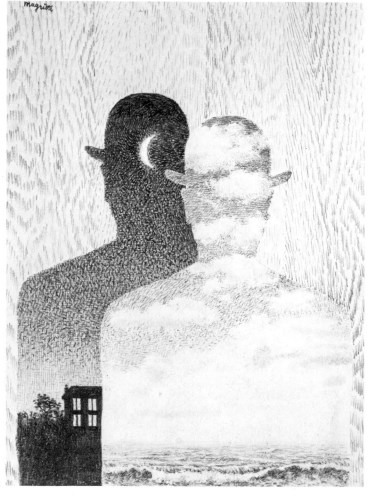

128

125. *The Good Faith*. 1962.
Oil on canvas, 40×32 cm.
Private collection, Brussels.

126. *The Son of Man*. 1964.
Oil on canvas, 116×89 cm.
Harry Torczyner Collection, New York.

127. *The Open Door*. 1965.
Oil on canvas, 160×164 cm.
Private collection, Belgium.

128. *The Thought That Sees*. 1965.
Lead pencil, 40×29.7 cm.
The Museum of Modern Art, New York.

129. *The Domain of Arnheim*. 1962.
Oil on canvas, 146×114 cm.
Mme. René Magritte Collection, Brussels.

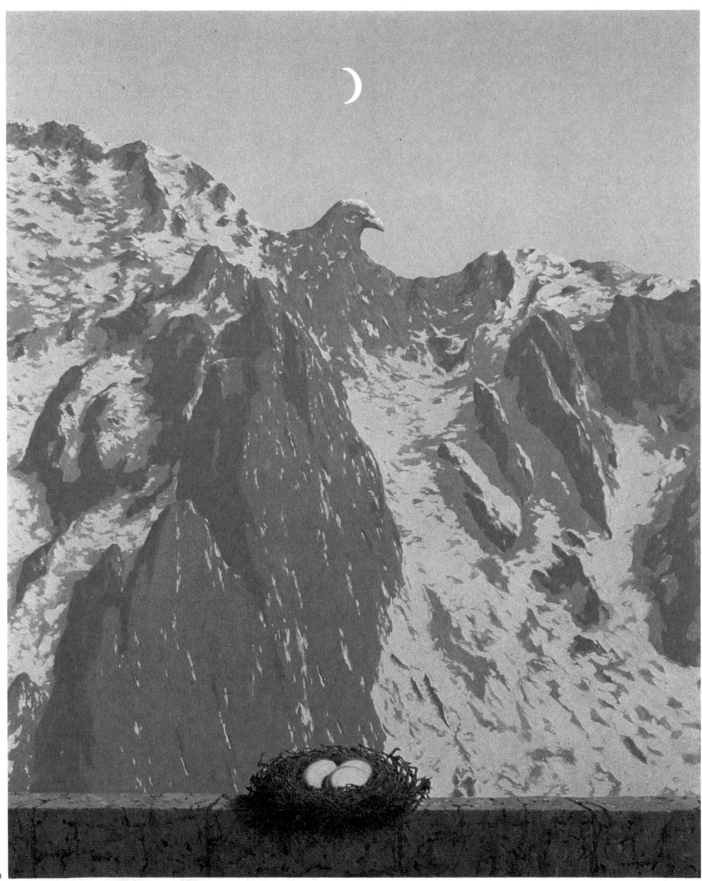

130. *The Great War*. 1964.
Oil on canvas, 80 × 61 cm.
Gillion Crowet Collection, Brussels.

131. *Carte Blanche*. 1965.
Oil on canvas, 81 × 65 cm.
Paul Mellon Collection, Washington, D.C.

130

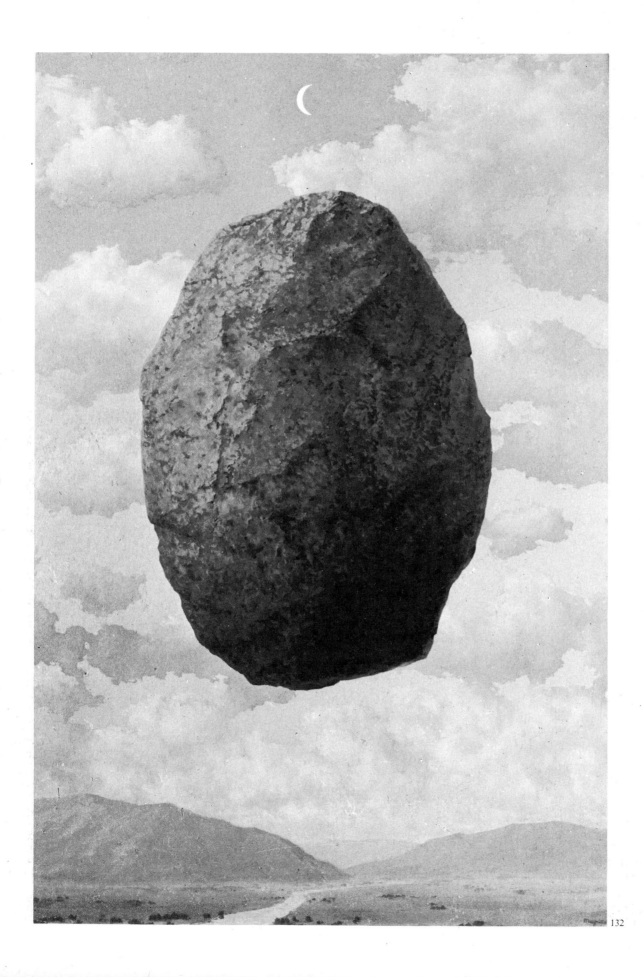

132

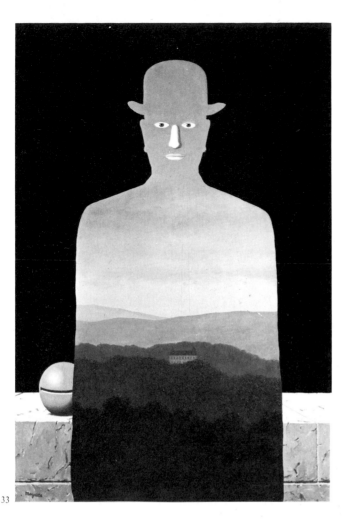

133

132. *The Sense of Reality*. 1963.
Oil on canvas, 175 × 115 cm.
Private collection, Great Britain.

133. *The King's Museum*. 1966.
Oil on canvas, 130 × 89 cm.
Arturo Álvez Lima Collection, Paris.

134. *Decalcomania*. 1966.
Oil on canvas, 81 × 100 cm.
Mme. Perelman Collection, Brussels.

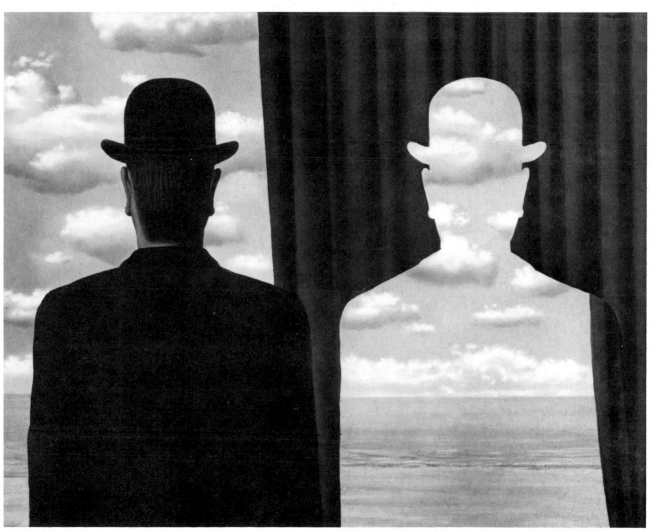

134

135. *The Field Glass*. 1963.
 Oil on canvas, 175.5 × 116 cm.
 Collection of the Menil Foundation, Houston.

136. *The Idol*. 1965.
 Oil on canvas, 54 × 65 cm.
 Private collection, Washington, D.C.

135

136

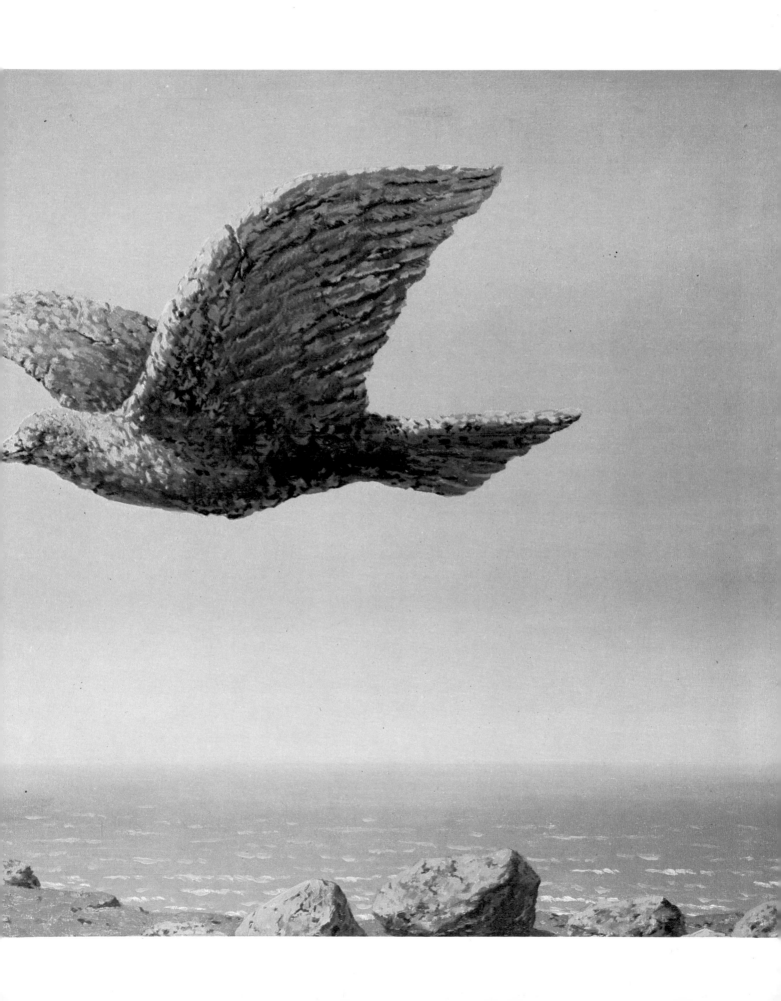

137. *The Sweet Truth*. 1966.
 Oil on canvas, 89.2 × 120.5 cm.
 Collection of the Menil Foundation, Houston.

138. *The Sweet Truth*. 1966.
 Pencil on paper, 18 × 32 cm.
 Mme. Denise Wiseman Collection, New York.

139. *The Sweet Truth* (detail).

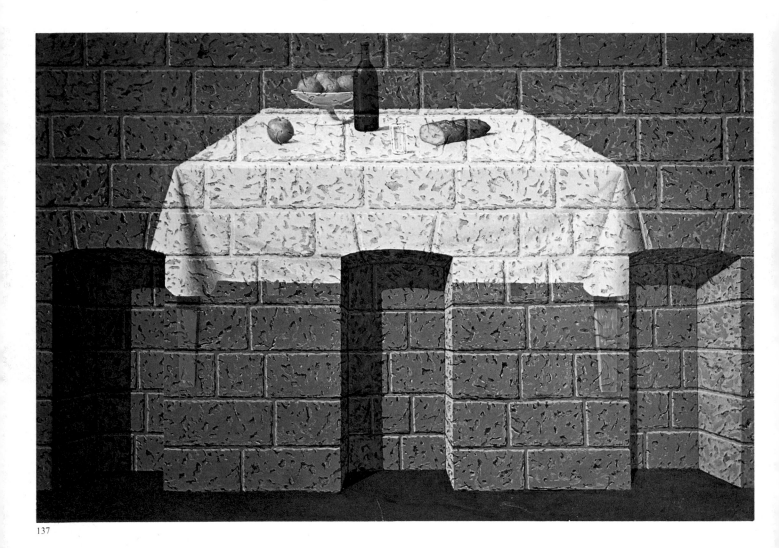

137

138

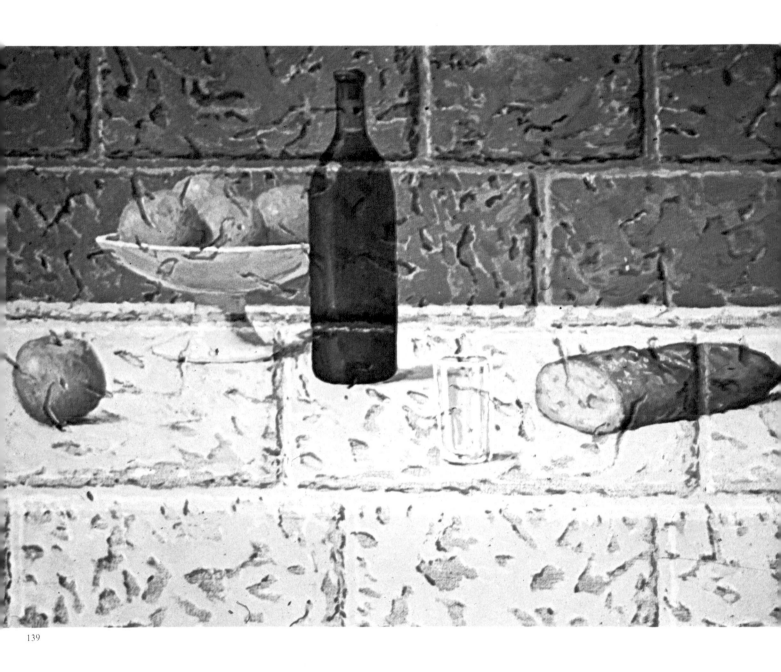

139

140. *Search for the Truth*. 1966.
Oil on canvas, 146×114 cm.
Musées Royaux des Beaux-Arts, Brussels.

141. *The Beautiful Relations*. 1967.
Oil on canvas, 40×32 cm.
M. and Mme. Pierre Scheidweiler Collection, Brussels.

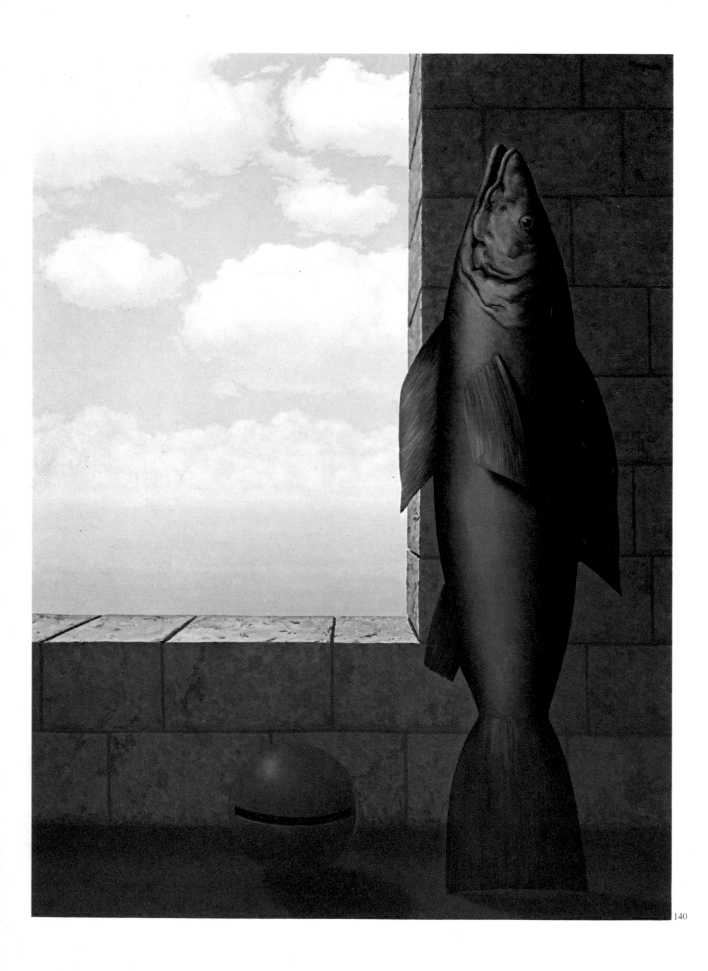

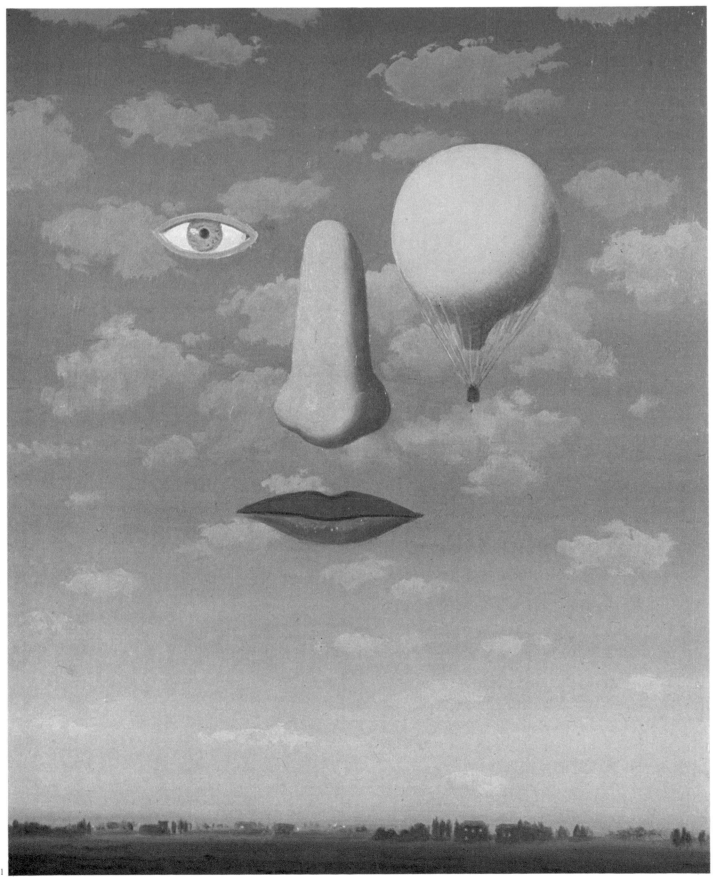

142

142. *The Devil's Smile*. 1966.
Colored pencil, 35 × 26.5 cm.
Private collection, New York.

143. *The Last Scream*. 1967.
Oil on canvas, 80 × 65 cm.
Dr. Jean Robert Collection, Brussels.

144. *La Gioconda*. 1967.
Gilded bronze, 245 × 168 × 98 cm.
Private collection, Brussels.

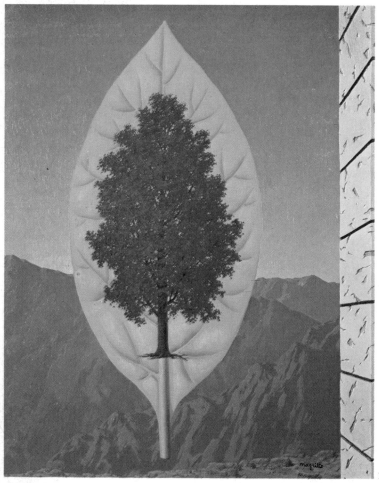

143

144

145. *The Idea*. 1966.
 Oil on canvas, 41 × 33 cm.
 Private collection.

146. *The Art of Living*. 1967.
 Oil on canvas, 65 × 54 cm.
 Private collection.

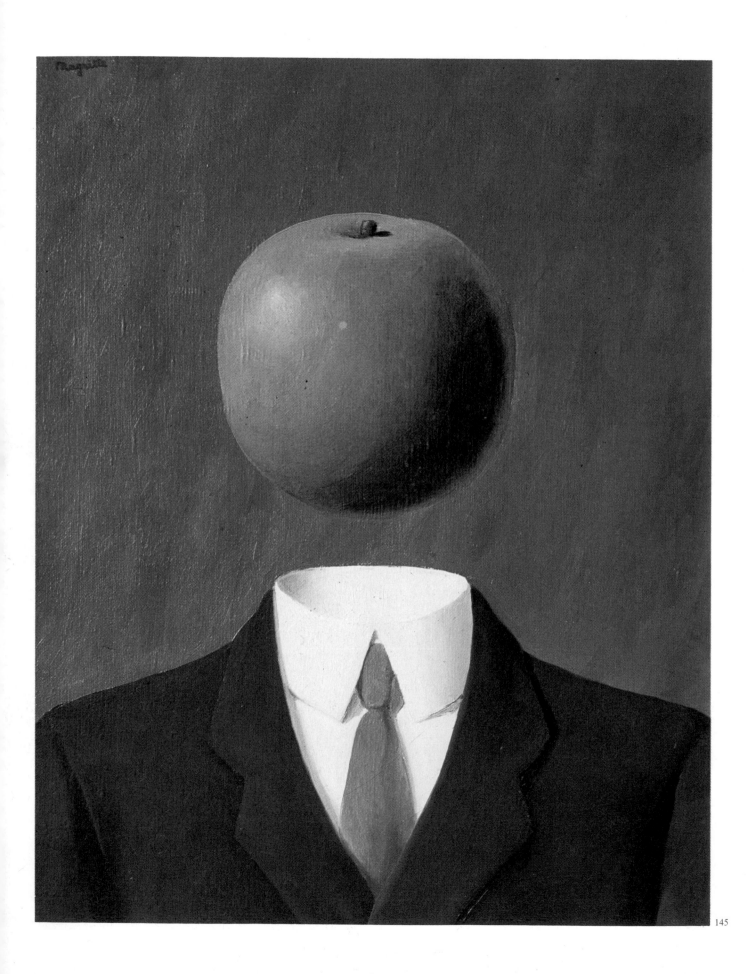

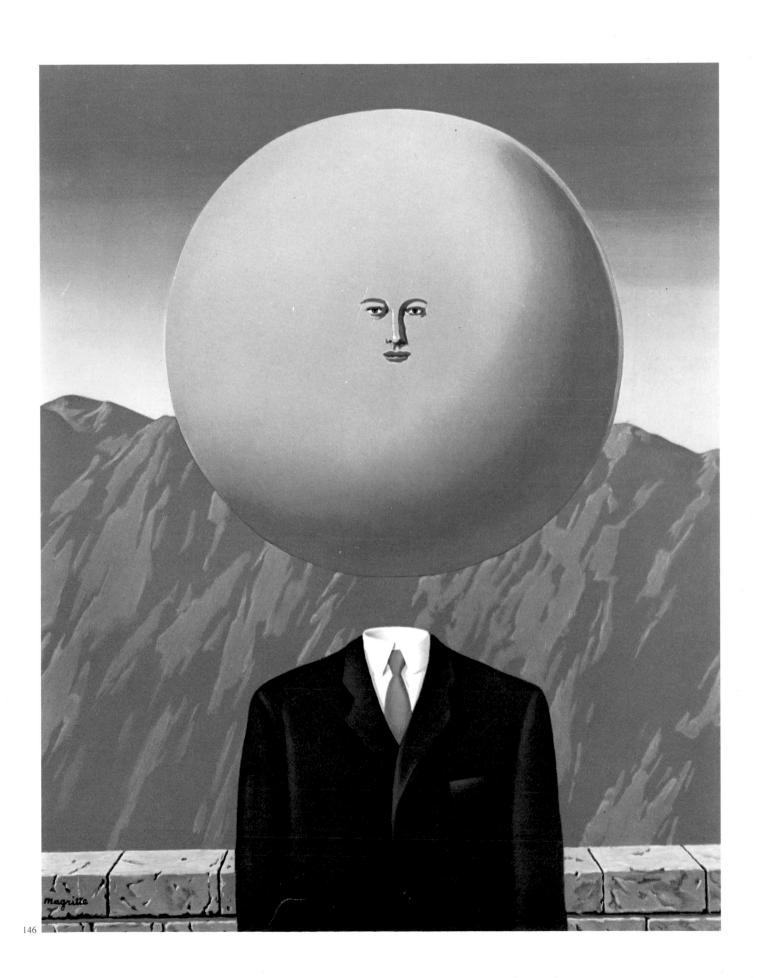

LIST OF ILLUSTRATIONS

58. *The Large Family*. 1947.
Oil on canvas, 100×81 cm.
Nellens Collection, Knokke-le-Zoute, Belgium.

59. *The Liberator*. 1947.
Oil on canvas, 99×79 cm.
Los Angeles County Museum of Art, Los Angeles.

60. *The Flavor of Tears*. 1948.
Oil on canvas, 58×48 cm.
Richard S. Zeisler Collection, New York.

61. *The Empire of Lights*. 1948.
Oil on canvas, 100×80 cm.
Private collection, Brussels.

62. *The Empire of Lights II*. 1950.
Oil on canvas, 79×99 cm.
The Museum of Modern Art, New York.

63. *The Empire of Lights*. 1958.
Oil on canvas, 49.5×39.5 cm.
Private collection, New York.

64. *The Empire of Lights*. 1953.
Oil on canvas, 37×45 cm.
Arnold Wessberger Collection, New York.

65. *The Empire of Lights*. 1954.
Oil on canvas, 146×114 cm.
Musées Royaux des Beaux-Arts, Brussels.

66. *Prince Charming*. 1948.
Gouache, 45×32 cm.
M. and Mme. Louis Scutenaire Collection, Brussels.

67. *The Pebble*. 1948.
Oil on canvas, 110×80 cm.
Mme. René Magritte Collection, Brussels.

68. *Lola de Valence*. 1948.
Oil on canvas, 100×60 cm.
M. and Mme. Louis Scutenaire Collection, Brussels.

69. *Dark and Handsome*. 1950.
Oil on canvas, 58×48 cm.
The Israel Museum, Jerusalem.

70. *The Dark Glasses*. 1951.
Oil on canvas, 57.7×48.5 cm.
Private collection, New York.

71. *Siren Song*. 1952.
Oil on canvas, 100×81 cm.
Private collection, United States.

72. *The Song of the Violet*. 1951.
Oil on canvas, 100×81 cm.
Private collection, Brussels.

73. *The Married Priest*. 1950.
Oil on canvas, 46×58 cm.
Mme. René Magritte Collection, Brussels.

74. *Pandora's Box*. 1951.
Oil on canvas, 46.5×55 cm.
Yale University Art Gallery, New Haven, Connecticut.

75. *The Magician* (self-portrait with four arms). 1952.
Oil on canvas, 35×46 cm.
Mme. J. Van Parys Collection, Brussels.

76. *The Blow to the Heart*. 1952.
Oil on canvas, 45×37 cm.
Richard S. Zeisler Collection, New York.

77. *Personal Values*. 1952.
Oil on canvas, 81×100 cm.
Private collection, New York.

78. *Golconde*. 1953.
Gouache, 15×17 cm.
M. and Mme. Louis Scutenaire Collection, Brussels.

79. *Golconde*. 1953.
Oil on canvas, 81×100 cm.
Private collection, United States.

80. *The Good Example*. 1953. (Portrait of Alexandre Iolas).
Oil on canvas, 46×33 cm.
André Mourgues Collection, Paris.

81. Fragments of a letter from René Magritte to Marcel Mariën (1953) about the problem of the piano.

82. *The Happy Hand*. 1953.
Oil on canvas, 50×65 cm.
Private collection, United States.

83. *Holiday*. 1954.
Gouache, 33×28 cm.
Mme. Denise Wiseman Collection, New York.

84. *The Listening Room I*. 1953.
Oil on canvas, 80×100 cm.
William N. Copley Collection, New York.

85. *The Evening Dress*. 1955.
Oil on canvas, 80×60 cm.
Private collection, Brussels.

86. *Memory of a Voyage*. 1955.
Oil on canvas, 163×130 cm.
The Museum of Modern Art, New York.

87. *The Poet Rewarded*. 1956.
Oil on canvas.
Private collection, United States.

88. *The Masterpiece* or *The Mysteries of the Horizon*. 1955.
Oil on canvas, 49.5×65 cm.
Arnold L. Weissberger Collection, New York.

89. *Euclidean Walks*. 1955.
Oil on canvas, 163×130 cm.
The Minneapolis Institute of Arts, Minneapolis.

90. *The Banquet*. 1956.
Gouache, 36×47 cm.
Private collection, United States.

91. *The Legend of the Centuries*. 1950.
Gouache, 25×20 cm.
Private collection, United States.

92. *The Legend of the Centuries*. 1958.
Pen-and-ink and pencil, 18×10 cm.
Harry Torczyner Collection, New York.

93. *The Hole in the Wall*. 1956.
Oil on canvas, 100×80 cm.
Hans Neumann Collection, Caracas.

94. *Justice Has Been Done*. 1958.
Oil on canvas, 39.5×29.2 cm.
Private collection, New York.

95. *God's Drawing Room*. 1958.
Oil on canvas, 43×59 cm.
Arnold Weissberger Collection, New York.

96. *The Golden Legend*. 1958.
Oil on canvas, 95×129 cm.
Private collection, New York.

97. *The Power of Things*. 1958.
Oil on canvas, 50.5×57 cm.
University of St. Thomas Collection, Houston.

98. *Painted Bottle*. Undated.
Height: 29 cm.
M. and Mme. Marcel Mabille Collection, Rhode-St-Genèse, Belgium.

99. *The Lady*. Undated.
Painted bottle; height: 32 cm.
Mme. René Magritte Collection, Brussels.

100. *Sky*. Undated.
Painted bottle; height: 30 cm.
Mme. René Magritte Collection, Brussels.

101. *The Time of the Wine Harvest*. 1959.
Oil on canvas, 130×160 cm.
Private collection, Paris.

102. *The Castle of the Pyrenees*. 1959.
Oil on canvas, 200×140.5 cm.
Harry Torczyner Collection, New York.

103. *The Anniversary*. 1959.
Oil on canvas, 89.5×116.5 cm.
Art Gallery of Ontario, Toronto.

104. *The Battle of the Argonne*. 1959.
Oil on canvas, 49.5×61 cm.
Tazzoli Collection, Turin.

105. *The Tomb of the Wrestlers*. 1960.
Oil on canvas, 89×117 cm.
Harry Torczyner Collection, New York.

106. *A Simple Love Story*. 1958.
Oil on canvas, 40×30 cm.
Galleria La Medusa, Rome.

107. *Project for a Difficult Crossing*.
Pen-and-ink and pencil, 13×13 cm.
Harry Torczyner Collection, New York.

108. *The Postcard*. 1960.
Oil on canvas, 70×50.2 cm.
Private collection, United States.

109. *Portrait* (M. Merlot). 1961.
Oil on canvas.
Merlot Collection, Brussels.

110. *Germaine Nellens*. 1962.
Gouache, 36×24 cm.
Nellens Collection, Knokke-le-Zoute, Belgium.

111. *The Beautiful World*. c. 1960.
Oil on canvas, 100×81 cm.
Private collection, Brussels.

112. *The Memoirs of a Saint*. 1960.
Oil on canvas, 80×100 cm.
Collection of the Menil Foundation, Houston.

113. *Plagiarism*. 1960.
Gouache, 30×25 cm.
Private collection, New York.

114. *The Country of Marvels*. c. 1960.
Oil on canvas, 55×46 cm.
Private collection, Brussels.

115. *The Waterfall*. 1961.
Oil on canvas, 80×99 cm.
Private collection.

116. *The Waterfall*. 1961.
Gouache, 37×45 cm.
Private collection, Gstaad.

117. *A Little of the Bandits' Soul*. 1960.
Oil on canvas, 65 × 50 cm.
Private collection.

118. *The Call of Blood*. 1961.
Oil on canvas, 90 × 100 cm.
Private collection, Brussels.

119. *The Bosom*. 1961.
Oil on canvas, 90 × 110 cm.
Private collection, Brussels.

120. *The Unmasked Universe*.
Oil on canvas, 75 × 91 cm.
Mme. Crik Collection, Brussels.

121. *The Natural Graces*. 1962.
Oil on canvas, 40 × 32 cm.
Mme. Suzanne Ochinsky Collection, Brussels.

122. *The Beautiful Realities*. 1963.
Pencil, 15 × 11 cm.
Harry Torczyner Collection, New York.

123. *The Exception*. 1963.
Oil on canvas, 33 × 41 cm.
Galerie Isy Brachot, Brussels.

124. *The Beautiful Realities*. 1964.
Oil on canvas, 50 × 40 cm.
Galerie Isy Brachot, Brussels.

125. *The Good Faith*. 1962.
Oil on canvas, 40 × 32 cm.
Private collection, Brussels.

126. *The Son of Man*. 1964.
Oil on canvas, 116 × 89 cm.
Harry Torczyner Collection, New York.

127. *The Open Door*. 1965.
Oil on canvas, 160 × 164 cm.
Private collection, Belgium.

128. *The Thought That Sees*. 1965.
Lead pencil, 40 × 29.7 cm.
The Museum of Modern Art, New York.

129. *The Domain of Arnheim*. 1962.
Oil on canvas, 146 × 114 cm.
Mme. René Magritte Collection, Brussels.

130. *The Great War*. 1964.
Oil on canvas, 80 × 61 cm.
Gillion Crowet Collection, Brussels.

131. *Carte Blanche*. 1965.
Oil on canvas, 81 × 65 cm.
Paul Mellon Collection, Washington, D.C.

132. *The Sense of Reality*. 1963.
Oil on canvas, 175 × 115 cm.
Private collection, Great Britain.

133. *The King's Museum*. 1966.
Oil on canvas, 130 × 89 cm.
Arturo Álvez Lima Collection, Paris.

134. *Decalcomania*. 1966.
Oil on canvas, 81 × 100 cm.
Mme. Perelman Collection, Brussels.

135. *The Field Glass*. 1963.
Oil on canvas, 175.5 × 116 cm.
Collection of the Menil Foundation, Houston.

136. *The Idol*. 1965.
Oil on canvas, 54 × 65 cm.
Private collection, Washington, D.C.

137. *The Sweet Truth*. 1966.
Oil on canvas, 89.2 × 120.5 cm.
Collection of the Menil Foundation, Houston.

138. *The Sweet Truth*. 1966.
Pencil on paper, 18 × 32 cm.
Mme. Denise Wiseman Collection, New York.

139. *The Sweet Truth* (detail).

140. *Search for the Truth*. 1966.
Oil on canvas, 146 × 114 cm.
Musées Royaux des Beaux-Arts, Brussels.

141. *The Beautiful Relations*. 1967.
Oil on canvas, 40 × 32 cm.
M. and Mme. Pierre Scheidweiler Collection, Brussels.

142. *The Devil's Smile*. 1966.
Colored pencil, 35 × 26.5 cm.
Private collection, New York.

143. *The Last Scream*. 1967.
Oil on canvas, 80 × 65 cm.
Dr. Jean Robert Collection, Brussels.

144. *La Gioconda*. 1967.
Gilded bronze, 245 × 168 × 98 cm.
Private collection, Brussels.

145. *The Idea*. 1966.
Oil on canvas, 41 × 33 cm.
Private collection.

146. *The Art of Living*. 1967.
Oil on canvas, 65 × 54 cm.
Private collection.